Carving and

The Swedish Style

Gert Ljungberg
Inger A:son-Ljungberg

Lark Books

Text and illustrations: the authors
Graphic design: Ulf Lindahl
Repro: Fägerblads Repro AB, Västerås
Text set up and "RIPPNING": Ljungbergs
Sätteri AB, Köping
Translated from the Swedish: Edith Matteson
Editor of U.S. Edition: Kathleen Sheldon

Library of Congress Cataloging-in-Publication Data
Ljungberg, Gert
 [Karva, snida, tälja. English]
 Carving and whittling : the Swedish style / Gert Ljungberg,
Inger A:son-Ljungberg.
 p. cm.
 Includes index.
 ISBN 1-887374-40-x (pbk.)
 1. Wood-carving. 2. Wood-carving—Sweden. I. A:son-Ljungberg,
Inger, 1948- II. Title.
TT199.7.L58 1998
736'.4'09485—dc21 97-44387
 CIP

10 9 8 7 6 5 4 3 2 1

Published in 1998 by Lark Books
50 College St.
Asheville, NC 28801, USA

Originally published by ICA bokförlag under the title *Karva, Snida, Tälja*,
by Gert Ljungberg and Inger A:son-Ljungberg

Distributed by Random House,Inc., in the United States, Canada,
 the United Kingdom, Europe,and Asia
Distributed in Australia by Capricorn Link (Australia) Pty Ltd.,
 P.O. Box 6651, Baulkham Hills Business Centre, NSW 2153, Australia
Distributed in New Zealand by Tandem Press Ltd., 2 Rugby Rd.,
 Birkenhead, Auckland, New Zealand

Thanks to the museum at Svaneholm Castle and to Bjärnum's Prehistory and Local
History Society. Most photos and older objects came from these museums. Alve
Nilsson's whittled figures on pages 114 and 116 and Per Ingvar Olsson's figures on
page 116 came from there as well. The photo on page 28 is from the "Döderhultar"
museum in Oskarshamn. The wooden objects on pages 82, 92, 93, 110, 111, 113,
and 137 were made by students at ISF and the University of Linköping.

Printed in Hong Kong

ISBN 1-887374-40-x

Contents

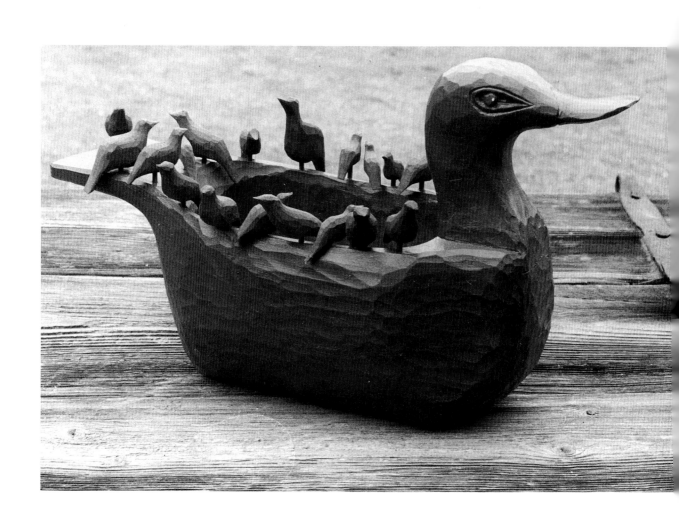

Foreword

Roughly carved duck-shaped bowl with a number of small birds on the edge.

As early as the hunting and gathering societies, people made simple utensils and tools for daily use and for ritual purposes. Since wood was the material most often used for these tools, woodworking for household purposes continued to be important for a long time in woodland cultures. In some cultures around the world this type of woodworking is still extremely important. In our culture, however, dependency on woodworking and handcrafts has decreased significantly. For us, relaxation and recreation are the most important functions of woodworking.

While woodworking can be done in various ways, the most important and natural has been working with cutting tools—everything from the rough stone axes of the Stone Age to today's refined axes, knives, chisels, and gouges. School children, eager to hollow out and shape a bowl from a piece of wood, usually display the same enthusiasm for, and pride in, their work as the hobby woodworker who turns a green piece of wood into a ladle or scoop while working at the woodpile or out in the forest. Creating something beautiful and useful from a piece of material that can be shaped gives a feeling of satisfaction and harmony.

In writing this book we hope to give you a little historical background and teach some of the technical knowledge that is a prerequisite for successful woodworking. But above all we want to inspire you to cut, carve, and whittle.

Gert Ljungberg and Inger A:son-Ljungberg

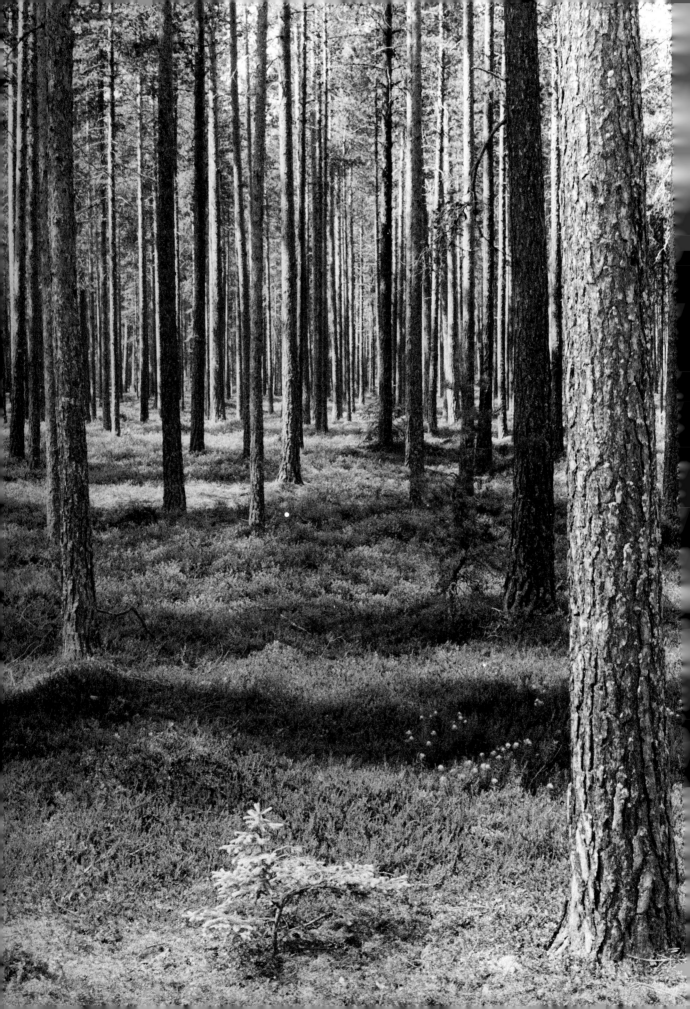

Trees

Pine is one of the dominant trees in the Northern Hemisphere. (In Sweden it is the second most common tree after the spruce.) The best pine forests are in northern climes where slower growth makes the wood tighter. Unlike spruce forests, pine forests are open and light, allowing room for undergrowth: often blueberries and lingonberries.

According to Nordic mythology, the first two people, Ask and Embla, were formed from a fallen ash and a fallen elm tree that Odin (the supreme god in Norse mythology) blew life into. Odin's brothers Vili and Ve gave them wits and the ability to hear and see.

This story of creation, as beautiful as the one in the Bible, is a story where the trees and their wood are at the center. Considering that wood is undoubtedly the material that meant the most for the development of Swedish culture, it's not surprising that it was used to symbolize human origins.

While Christianity has caused most of us in Sweden to forget the mythology of the oldest and most Nordic gods, many of the customs that we still follow here are based on the beliefs of our ancestors. During Easter and Lent, families decorate with birch twigs, and at Midsummer they raise the maypole decorated with birch leaves. Both of these traditions are inherited from the time when Norse gods were worshipped.

What is a tree? Well, it is a woody plant that when fully developed reaches a height of over 16 feet (almost 5m) and has a trunk that supports the crown. If, on the other hand, the mature plant is shorter than 16 feet, it is called a bush. Then it usually lacks an actual trunk, and its

crown is almost directly on the ground. Naturally there are forms in-between: bushes that are unusually well developed and have become as stately as trees, and trees that have been hampered in their growth. One plant in Scandinavia that represents both of these types is juniper. In barren and exposed places along the coasts or in the mountainous regions, the juniper creeps along the ground, while in most other places it becomes a tall bush or sometimes even a tree. At Ljungbyhed, in southern Sweden, there is an entire juniper "forest" with a large number of junipers that can be considered trees.

The trees that we will discuss in this chapter are ones that grow in Sweden that are well suited to all types of woodworking. There are a number of other trees that may be suitable in certain cases, such as the various fruit trees. Of these, we will deal only with cherry in more detail. Dried pear and apple wood are way too hard to be suitable for woodworking. Apple wood often has the additional problem of whorls, which cause the wood to crack when drying. However, apple and pear wood that is still green can be successfully worked into spoons and ladles. Another fruit tree worth mentioning is plum. The quality of plum wood resembles that of cherry in many ways, but it has even livelier markings, often with red streaks and violet sections.

In the following section we will introduce a handful of trees with woods that are appropriate for carving. We will attempt to give a picture not only of the qualities of the wood but of the importance of the wood in historical use and in Swedish folklore.

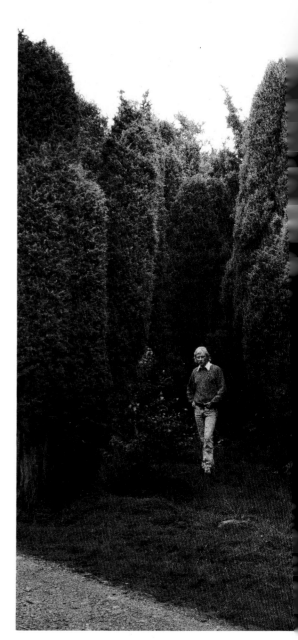

In addition to the trees mentioned in the text, the following North American trees are also well suited to woodworking:

basswood

boxwood

butternut

cedar

chestnut

holly

maple

oak

sycamore

Note: Refer to the map of Sweden on page 166 for places mentioned in the text.

A rare Swedish juniper forest; note the impressive columns. These have grown into real trees of considerable height and thickness but are not unparalleled in this regard. What *is* noteworthy is how many of these large trees there are.

Juniper

Juniper is considered the world's most widespread pine tree. Juniper is a light-loving tree that often grows scattered in thin woods, at the edges of fields, and along power lines.

The so-called berries (actually cones) do not ripen until the second year, when they go from the light green of their first year to a dark bluish gray color. Some birds like to eat them, and they are used as a strong aromatic spice in Swedish cuisine.

In the old days the needles, which are sharp as an awl at the tip, were believed to offer protection against all sorts of witchcraft and ghosts. Because the cones have a fairly distinct cross pattern where the shell grows together, juniper has also been associated with Christian symbolism.

Juniper wood is tight and solid, without being hard. Even the branches are relatively soft, making the wood easy to work with cutting tools. Juniper wood is yellowish white to yellowish brown in color.

The aromatic smell that comes from working with juniper has contributed to its popularity among woodworkers. In olden times the wood was used as a stopper in boats, the twigs were woven into baskets, and the withe (a slender branch or twig) was used for fence binding. Thanks to its pleasant odor, juniper wood has been used for small household utensils, and the pungent odor that spreads when the wood and needles are burned has made it popular for smoking meats since olden times.

Juniper with branches and "berries" (technically, cones).

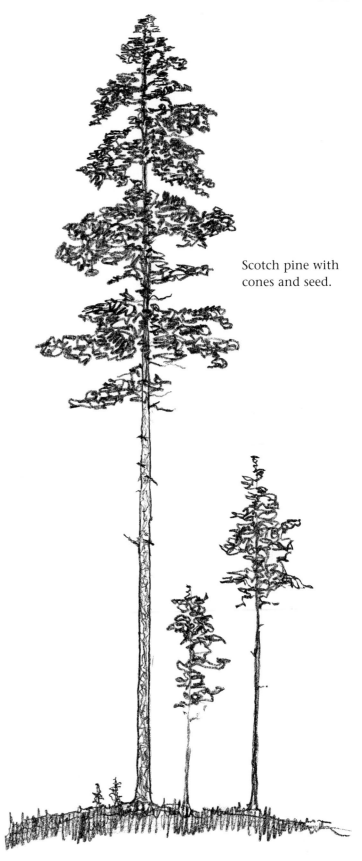

Scotch pine with
cones and seed.

Pine

The majority of forests in the
Northern Hemisphere are conifer-
ous, with pine or the Scotch pine
dominating in many places. In
Sweden, pine is the most common
tree after the spruce, and the tree
grows all over Europe, from the
British Isles to eastern Siberia and
from the Mediterranean to north-
ernmost Scandinavia.

Pine wood without a doubt is
the wood that has meant the most
for Sweden's cultural development.
We see close-grained and heavily
resinous pine in buildings that are
several hundred years old. These
timbered buildings are covered
with hand-planed pine shingles.
Tar, used in treating the timbered
walls, was burned from the resin-
rich pine stumps. Tar burning was
of great economic importance at
various times and was an impor-
tant export article, primarily to the

ship-building nations of Europe. The majority of the pitch came from the resinous stumps, but even into the 1800s, because tar was more valuable than the wood itself, pines trees of first-class lumber were used for tar burning. In this process, most of the bark was removed from the lower part of the trunk. Only a narrow strip was left on the north side of the tree to serve as contact between the root and the crown so that the tree didn't die completely. The tree was left this way for a couple of years to store the pitch and then the bark was completely removed as high as could be reached. After a couple more years of collecting pitch, the tree was ready to be cut down, chopped up into pitch wood, and placed in the tar fire.

Charcoal was another important product that the forests, and pine in particular, contributed. Of course pine also provided wood for cabinet making and furnishings (it was absolutely the best raw material for the latter), and in really olden times pine tar sticks provided light for working during the dark winters.

Even today, pine is still the best woodworking and carpentry wood, even though it may be difficult to get hold of pine that is of as good a quality as before (at least in southern Sweden). Through modern forestry the growth rate of pine has been significantly increased and the annual rings have become wider. This loose-grained pine can be somewhat difficult to work because the fibers of the soft spring wood flake off easily. The best wood for chip carving and similar woodworking is close-grained heartwood that is cut radially, so that woodworking takes place across the annual rings.

Pine is usually homogeneous and grows straight, but there is a lot of difference in the hardness of spring and fall wood. The heartwood is brown or reddish brown while the sap wood has a yellowish white tone.

Next to oak, pine reaches the oldest age of all our trees. In Svärdsjö, in Dalarna, a pine was cut down in 1912 that was calculated to be 654 years old. It began growing in the middle of the 1200s—about the same time that Stockholm was founded. The age at which a pine forest is cut is normally slightly over 100 years.

Pine doesn't get as tall as spruce, but it does get as thick. It sometimes grows thick and low. In folklore such trees were the so-called sacrificial pine, and the ones that stood near the edge of a road were often called "drinking pines." In those days travelers stopped and refreshed themselves under such a tree before continuing their journey. These slightly strange trees were more or less automatically protected because nobody dared to cut them down for fear of the supernatural spirits that lived in the tree.

Speaking of "drinking trees," pine also provides a spice for aquavit. The young annual shoots, the so-called pine trash, were valued as taste additives and yielded what was considered a healthful drink.

Alder

Alder trees are characterized by their broad-toothed leaves and woody female catkins. With alder, these catkins remain on the tree to form cones instead of falling off as they do on the closely related birch. The roots of alder are also special because they usually form knots that can grow as large as apples. These knots contain mushrooms that turn the nitrogen in the air into protein, which in turn enables the

alder to survive, even in soil that is low in nitrogen. They can be planted almost anywhere, as long as the site is moist enough.

Alder is among the trees that are viewed negatively in folklore and have a bad reputation: they are a sort of symbol for evil.

Only weak light penetrates the large bluish green leaves of the common alder, and in the darkness underneath, the trunks often stand in acidic, swampy water. In the fall the alder trees' leaves fall off suddenly after the first frost. One day the trees are a lush green and, the next, the leaves float down heavily, forming a black, rapidly decaying carpet on the ground. These factors, combined with the

fact that the saw turns the wood a blood red color, have certainly contributed to the negative view of alder in folklore.

Nevertheless alder wood was used to make all types of wooden products in old-time farming society. Because the wood is light, feels soft against the skin, and is easy to split and shape, alder has long been used for wooden clogs and the soles of slippers. For these reasons it has also been useful in making yokes used to carry buckets from the well. Because alder is so easy to shape and whittle, it has been carved into everything from toys to troughs, bowls, spoons, and ladles. Another reason alder is suitable for these household items is that the wood has almost no smell or taste.

Today alder has become more and more popular for furniture making and it has even been used for veneer recently, because it can be stained to resemble other types of wood. Alder is good for the types of woodworking that we are discussing in this book, but it is important that sharp tools with relatively pointy edges are used to avoid chopping off the wood's extremely short fibers. They are particularly noticeable in gray alder that has been lying in moisture before the drying process.

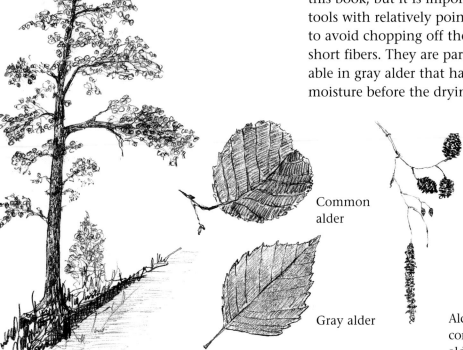

Common alder

Gray alder

Alder, the leaves of common alder and gray alder, and a female catkin and cones.

13

Birch

Birch is undoubtedly the wood that we consider the most Swedish. It's possible that primitive Scandinavian mountain birch spent the winter in protected places along the Norwegian fjords during the most recent ice age. Birch was the first type of tree to wander in, spreading at the same pace as the inland ice retreated. In addition, birch is the tree that is spread over the largest area of Sweden. It grows from the southern coast to the uppermost mountainous regions and all the way to the edge of the permanent glaciers.

The gracious form, the hanging branches in the silver birch, and the white trunks of the common birch are among the typical Swedish symbols often depicted in paintings of our countryside by our romantic painters.

Birch. Sweden's common birch (with single-toothed leaves) and silver birch (with double-toothed leaves and catkin).

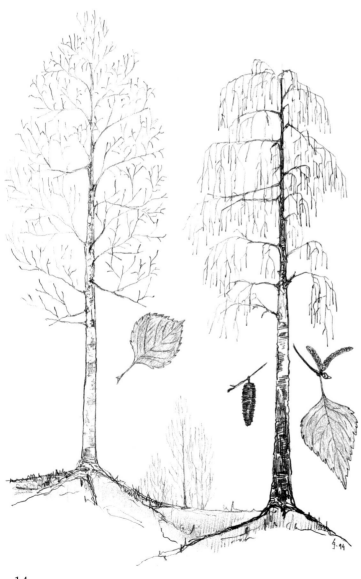

The "Ornäs" birch is recognized by its unusual deeply laciniated leaves.

Birch takes hold as a pioneer tree. It is the first tree to take over newly cleared fields and fields no longer being used as grazing land. Felled birches readily give off shoots, and birch seeds, thanks to their light weight, spread easily in the wind. A million birch seeds weigh just under half a pound (1 kg).

In their first years birch trees grow very quickly, but after about 70 years there is a definite stagnation and growth stops.

In old-time farming society birch was probably the most useful of all trees. Parts of the birch were used for various medicinal purposes. Its ashes were long an important ingredient in remedies for coughs. In addition birch leaves—rich in vitamin C—have been used as a remedy for scurvy. Tea can be brewed from fresh or dried birch leaves, and in the spring sap can be tapped and turned into an excellent drink and a sparkling wine.

Few trees produce as good and versatile a raw material for wood-working purposes as birch. We have made both woven and roped boxes from birch bark, and we have woven baskets and sewn lapped boxes from its roots. In the spring the outermost twigs, both with and without bark, can be tied into whisks and brooms. Both green and dried birch wood is excellent for bowls and dishes, whether made on lathes or carved. It is easy to work yet strong enough for such household utensils as ladles and spoons, and it does not give off a smell or

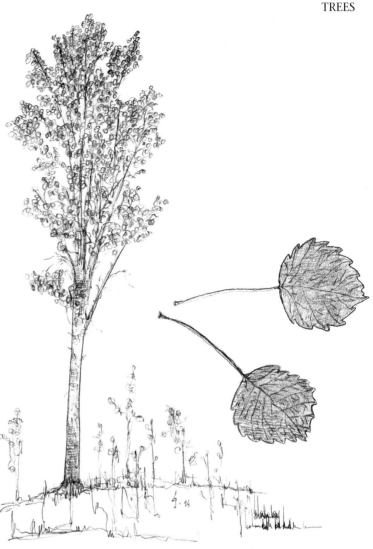

Aspen with leaves.

taste. And birch has a definite place in the Scandinavian blonde furniture tradition.

Aspen

Aspen belongs to the extensive family that includes willows and poplars. It was, along with the birch, one of the first trees to enter into the Scandinavian fields, and today it grows almost everywhere in the country. During its first years aspen grows extremely rapidly with annual shoots reaching three feet (almost a meter) in height. Large numbers of these develop from the roots, particularly after felling. (The tree is sometimes ring-barked to avoid this and prevent it from spreading.)

Poplar is closely related to aspen. Today they are often planted close together as a windbreak in exposed areas like the plains of southern Sweden, where they replace the old willows to a certain extent. Poplar wood is not as good for carving as that of aspen.

Aspen is a light-loving tree that can grow in close clusters in good fields. Because of their light requirement aspen usually reject their lower branches. These wither and fall off, and a thin, upward-lifting crown is formed.

Aspen trees in stands often resemble each other. They have similarly shaped branches, they leaf out at the same time in the spring, and their yellow or red fall colors appear at the same time. The reason for this is that they descend from the same mother plant and have similar genes.

Often folklore comes from a combination of gaps in scientific knowledge and a lively imagination. The quivering aspen leaves are an example of this. Today we know that the slightest breeze causes its leaves to quiver because the stems on the leaves are very flat on both sides. "In the absence of this knowledge, the whispering of the aspen on days without wind was considered strange," according to the book *Från al till tall* [*From Alder to Pine*]. "Other deciduous trees drooped silently, but the aspen quivered and whispered. There didn't seem to be any living explanations; something invisible (and probably dangerous) had to be the cause of such signs of uneasiness through the trees."

Aspen is primarily associated with Sweden's once prominent matchstick industry. The wood is extremely easy to split and grows relatively straight, making it an excellent raw material for this purpose.

If aspen is allowed to dry for a year so that the bark falls off, the wood becomes light, hard, and durable. For this reason farmers used it as fence wood. Today it is the raw material for sauna benches because it is soft and not too hot to sit on.

Aspen wood is light yellowish white or grayish white and sometimes has a little reddish element in the branches. It is relatively soft and easy to cut, but because it splits so easily it is not suitable for use in creating finely detailed wooden objects and carvings. However, it is worthy of a place on the woodworker's wood shelf.

Sallow and Willow

Sallow and willow both belong to the genus *Salix*. Willows were first introduced to Sweden by monks who used the tree for medicinal purposes. Several members of the Salix genus provide salicin, a substance that relieves headaches and reduces fever among other things.

It was Carl von Linné who recommended that farmers plant willows as protection after having seen "how the wind dries and removes the finest top soil into an invisible dust and thus daily emaciates the earth" during his travels in the level country in southern Sweden. After several years these trees, which are often cut to the ground (to get new shoots the next summer), gained their typical shape with low, thick, often hollow trunks and a crown of sprawling annual shoots. They have become a sort of symbol for Sweden's southern province of Skåne.

As far as woodworking is concerned, it is primarily the straight annual shoots of both the willow and the sallow that have been used for braiding baskets and barrel hoops. These annual shoots come

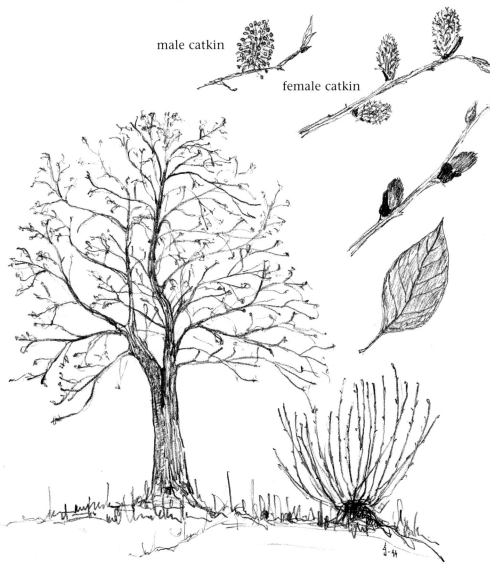

male catkin

female catkin

Sallow with male and female catkins and the spring flower buds and leaves.

17

Linden with
leaves and seeds.

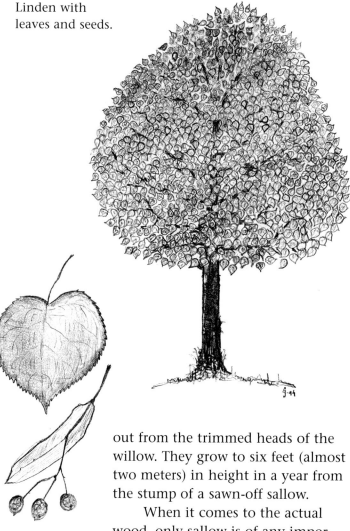

a stand with other deciduous trees, and large-leaved linden (*Tilia platyphylla*), a rare type nowadays (there are a few in western Sweden). A hybrid that comes from these two is the common linden (*Tilia x europea*). This is the type that grows in parks and along avenues.

Linden trees grow to be very old, so they are suitable for planting as protective trees. (They were once believed to help protect farms with their good influence and serve as a dwelling place for supernatural beings.) Lindens can grow fairly large in the right kind of soil. Trees with thicker trunks have ridges and uneven areas out of which a number of small shoots grow. This creates roses in the wood with lively patterns. The wood is otherwise soft, smooth, and a uniform yellowish white color.

Linden is considered one of the absolute favorite woods of carvers and sculptors. Thanks to its softness it is easy to work with carving tools. At the same time it is relatively tough and doesn't split even when doing detailed carving.

However, it is not only the wood of the linden that is used, but formerly also its bark. Its thick and fibrous outer bark was previously used by carpenters as glue brushes. The tough inner bark was used for making bast, which could be twined into rope and reins, or woven into baskets. In order to produce the bast, the bark was rotted in seawater. After a few months the bast was ready to be flaked off and worked further.

out from the trimmed heads of the willow. They grow to six feet (almost two meters) in height in a year from the stump of a sawn-off sallow.

When it comes to the actual wood, only sallow is of any importance to woodworkers. Sallow wood is a beautiful yellowish white, or in older trees a more yellowish brown color, and a good wood for making wrapped boxes and for cutting into. It is relatively soft so tools have to be very sharp and have sharp, pointy edge angles to get good results.

Linden

Two types of linden are considered to have originated in Sweden: the small-leaved linden (*Tilia cordata*), which grows in southern Sweden, usually in

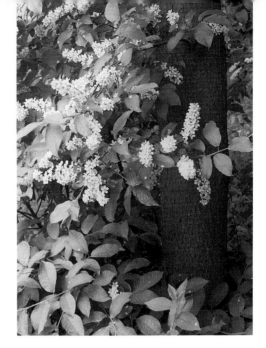

Charcoal from linden wood has also been of some importance. It is considered to be the best charcoal for drawing. The linden flowers, which come out later than flowers on most other trees, are also important and give an unusually fresh and good tea.

The cherry tree probably comes from the European bird cherry. In the spring the bird cherry is easy to recognize because of its rich spray of flowers with a strong odor. The wood is beautiful and is fairly well suited for carpentry.

Cherry

Cherry wood is undoubtedly the most beautiful, easily worked, and elegant wood you can imagine. With its smooth velvety surface alternating in yellowish white and grayish brown, greenish and red striped, it has lively patterns. It is easy to plane, good to cut, and possible to polish to an excellent finish. In fact, cherry can serve as a replacement for several other types of trees, particularly a number of tropical ones that there may be a shortage of in the future.

Closely related to cherry is the European bird cherry (*Prunus padus*) which blossoms in the spring with its strong-smelling sprays of flowers. Bird cherry grows rather gnarly and the wood is somewhat harder and lighter in color than cherry wood, but it also has beautiful, lively patterns.

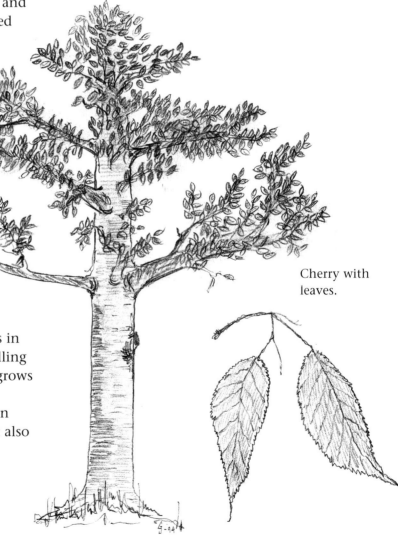

Cherry with leaves.

19

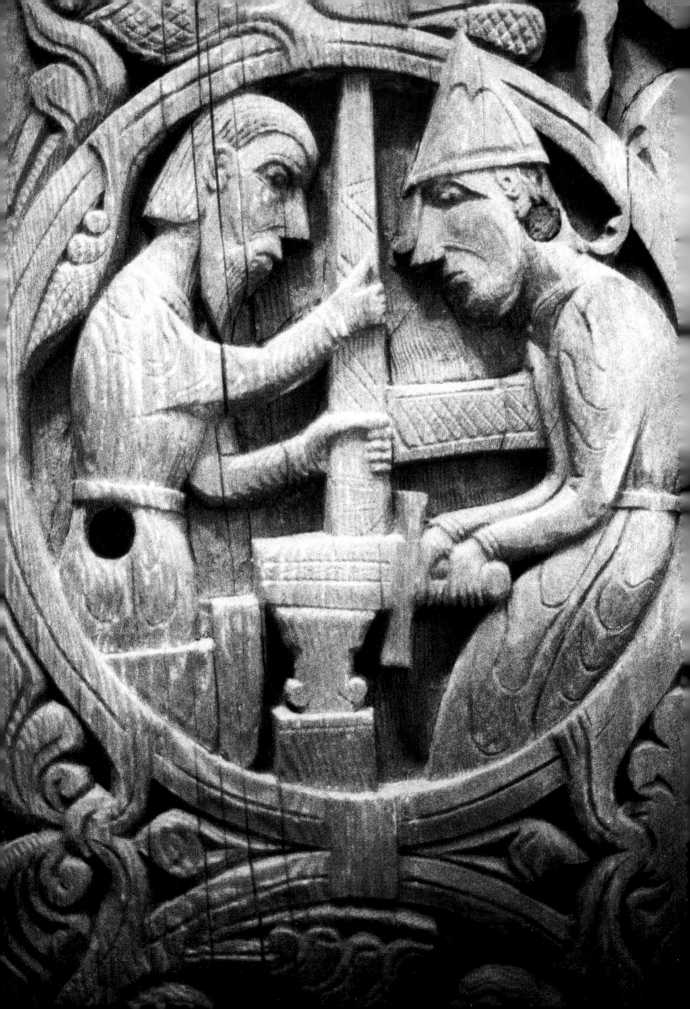

The Development of Woodworking

Detail from the doorway of a church from Norway, 1100s. It's strange that tales of the old Norse gods are found on Christian churches. This photo shows a detail from the entire story of Sigurd Favnesbane and Regin throwing a sword to kill the dragon Fafnir and then Sigurd roasting Fafnir's heart.

Some animals and birds use various "tools" (materials they find in their surroundings) to obtain and prepare their food. Humans also originally collected edible plants, berries, and seeds using sticks, stones, and similar tools from nature. We used leaves and parts of plants as containers for collecting seeds and berries.

Soon techniques were developed to make these objects more suited to their purposes. The sticks were given tips and the leaves were woven together into simple baskets. As the need for utilitarian objects and for the tools to make these objects increased, the materials used were still those in the surroundings: wood, first and foremost, and stone when a harder material was needed. Antler and bone came into the picture early, when humans became hunters. But wood, around us at all times, was the material used most often.

As the desire to decorate and beautify objects arose, woodcarving cultures emerged. The stone ax and sharp stone fragments were important early tools used to produce these decorations. Some coastal cultures, such as the totem carvers on the west coast of Canada and the seafaring Maori in New Zealand, ground hard shells sharp and used them for tools.

With the knowledge of metalwork came better tools, and in turn carving production increased. Not only axes but also knives and various wood chisels and gouges were developed, and wooden carvings became more and more detailed. They went from mostly engravings to finer and finer carvings with ornaments and relief patterns. The oldest wooden artifacts have been found in Egypt, which had skilled handicraft workers and the dry climate that is best for preserving wood. Many are the objects that followed the dead into the Egyptian sepulchral chambers and were preserved there for the afterworld.

There are endless examples of excellent Scandinavian woodworking dating all the way from Viking times onward. From their ships and the discoveries made with those ships, we know that the Vikings were skilled in working with wood. Twining dragons, winding serpents, and images of the Norse gods were common motifs in Viking carvings.

Later on, woodworking was also essential to farming society. Not only was wood the predominant building material, but most tools used for working the soil were made of wood, as were household utensils and furniture.

Because a farmer had to renovate and maintain his own objects and buildings, he was forced to be something of a jack-of-all-trades. Often it was during the dark winter evenings that handcraft work took place: the women with textiles and the men with wood. In the light of a burning tar stick or from the fire in the open fireplace the objects needed in the household were produced. Gifts made by suitors that have been preserved from those times reveal patient woodworking. The men really put all their skills

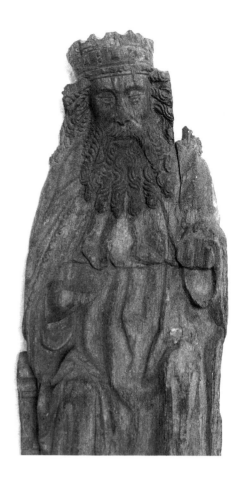

Scandinavian churches have numerous carved wooden sculptures and reliefs that illustrate Christian traditions and the people and events in the Christian stories. Some of these works were brought home from central and southern Europe as war booty. Oak was often used in these carvings. It is a hard and very thick material: hardly suitable for the work of a hobbyist. This figure (of unknown origins) probably dates from the 1400s.

to work to show their intendeds what handy guys they were.

Woodcarving provided relaxing work for lumbermen out in their log shacks during the long winter evenings. Often spoons and ladles for the housewife or toys for the children at home were made with the help of a knife. Many wooden horses and wooden figures were produced under these circumstances. The children themselves often learned woodworking at an early age. Rural children, who had only home-made toys, learned early to handle the knife to carve simple objects such as birch boats made for sailing in the puddles of melted snow in the spring and whistles carved in early summer when the bark came off mountain ash and sallow easily.

Gradually, town smiths and town carpenters took over more and more of the metal and woodworking in farming society, and from this came special handcraft workers and (in the city) craft guilds.

Mangle boards (used in pressing clothes) with horse shapes on the handle were common objects among suitors' gifts. This board from 1852 was made with a double horse head, which probably symbolizes the idea that there should be two to carry the load.

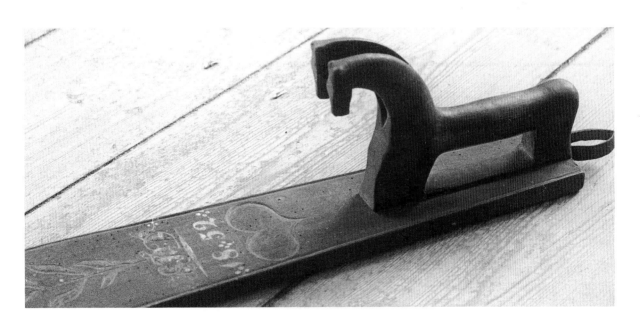

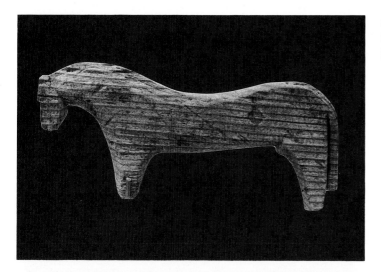

As early as Viking times the horse was found among the wooden toys made for children.

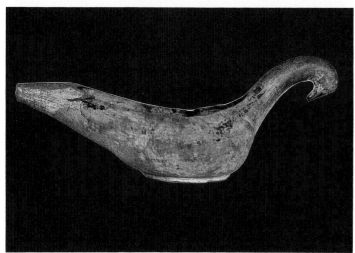

Wood growing crookedly or burls (knotty growths) on tree trunks often became the raw material for old-time household woodworking. "You don't get a wooden object when you need it: you get one when you find it instead" was a true saying. Many objects were made by hollowing out the wood and using the shape of the piece to determine the appearance of the finished product, such as this bowl with birdlike features.

With industrialization in the 1800s and onward much of the handcraft work became superfluous. Common knowledge of woodworking disappeared. Techniques were forgotten as locally produced utilitarian objects were replaced more and more by industrially mass-produced ones.

Eventually handcrafts shifted from having been important objects in daily life to now being works of art, the majority of which were only for looking at.

Carved troughs, ladles, and scoops were important household articles in farming society. The troughs were used for preserving and preparing food for both people and animals. Ladles were made in various shapes and sizes depending on what they were to be used for. The shapes of the scoops also varied to a certain extent, but they were usually very large and were made for scooping grain or flour.

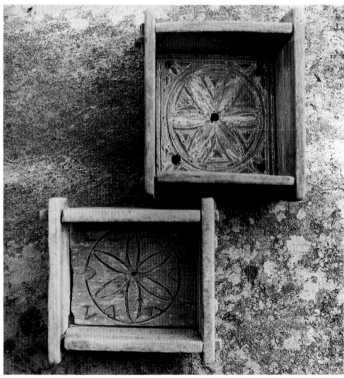

As a rule cheese molds were made with some type of chip carving at the bottom, which allowed better runoff and of course gave the cheese a beautiful pattern. In addition the decor may have been thought to have magical powers that would make the cheese successful.

Woodworking districts

Scandinavian woodworking is full of tradition and knowledge that was passed down from the time when the farming population was obliged to produce most of its own articles for everyday use.

This form of self-reliant housekeeping gradually led to the development of various woodworking districts around the Nordic countries. Dalarna is an example in Sweden of an area where the old woodworking traditions survived into modern times. Various techniques and distinctive characteristics developed in different Dalarna towns. Nusnäs near Mora is still a center for the production of the famous Dalarna horses. Since olden times the town of Venjan has had a deep tradition in the production of barrels, while Våmhus has distinguished itself for its fine chip baskets. Naturally Dalarna's rich woodworking tradition is also a result of access to good materials. The mature and tightly grained pinewood that grew there in olden times was suitable for these types of products.

Another area with corresponding material resources is in the Göinge district. The old-time farmers, who had a hard time supporting themselves on their stony fields alone, used woodworking for supplementary income. They worked in the woods and did woodworking during the winter months. In the spring and the fall it was time to sow and harvest. In the summer they managed to go down to the plains of Skåne to sell what they made during the winter.

After industrialization spread across Sweden a woodworking industry grew out of this tradition in the Göinge district. Small woodworking factories were started. Some of them gradually became furniture factories. The community of

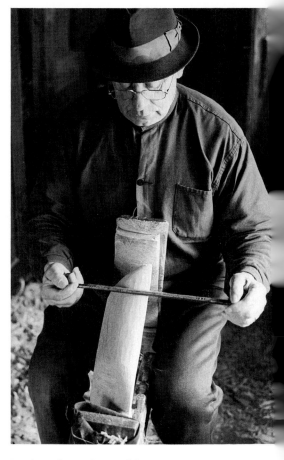

In the photo Samuel Jonasson is carving the outside of a trough with the help of a drawknife.

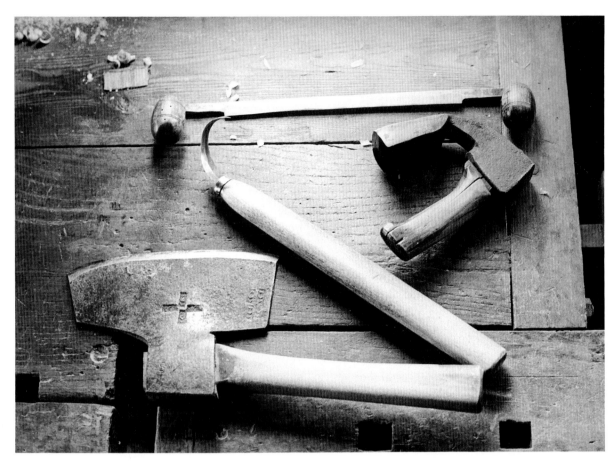

Samuel Jonasson's tools were not many, but functional. They were the broad ax for the first rough hewing, the cooper's adze, for the initial hollowing out of the wood, the drawknife for fine cutting on the outside, and the long-handled "digging iron" for the final cutting on the inside. This carving was always done across the direction of the grain, thereby avoiding resistance in the wood. Still, the tools had to be really sharp.

Bjärnum in northern Skåne was completely dominated by furniture making for a while. Another example is BRIO in Osby, which grew into a large, internationally known toy manufacturer that concentrates on wooden toys.

The "Döderhultar"

Axel Petersson was his name; he was born in Döderhult parish in Småland in 1868. That little odd person from Småland became known as the "Döderhultar." He also became one of our finest woodcarvers. He has been called our national sculptor, and there is no doubt that he was a master with the knife. No other has been able to express himself in such a simple and refined manner with the help of a carving knife and alder wood.

27

He whittled numerous cords of alder wood until sometimes there was almost nothing left for the fireplace. He whittled his figures out of alder because it was easy to work with, and he felt that it was "the right earth brown color" for the farming people of Småland. Of course, they were his main subjects. He depicted both the known and the unknown people of Småland: the town school teacher who handed out punishment to the young people and the assistant master at the grammar school at Oskarshamn. His group sculptures include *Recruit Enlistment*, where he depicts the shyness of the young men when the authorities measure them and enlist them into military service, and one of people gathered around the judicial bar as the rich man's son swears himself free of

Unlike any other sculptor of wood, Axel Petersson (the "Döderhultar") has depicted the people and animals of the farming society of Småland. His figures are carved in alder, which had the "right earth brown color for the people of Småland." Most of his figures have been painted with thin colors with the "earth brown" color left for the naked skin only.

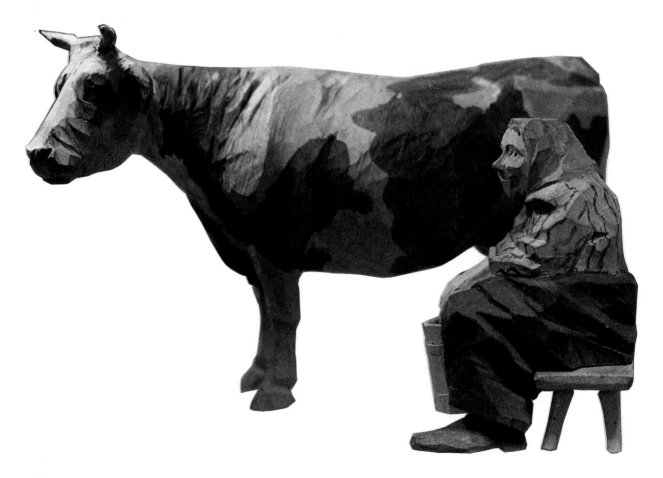

fatherhood while the lay assessor timidly looks down at the tabletop. He depicted not only people but also cattle in the farming society. "The cows are more thankful," he supposedly said. "They glare but don't pretend to understand more than they do. And they stand better. Four legs are always more stable than two. Damned if the cows don't also have more character as well."

At first he sold his figures for a few pennies or gave them away. Most people considered him worthless. But he had a particularly good relationship with his mother, and when he became famous and had exhibits in Stockholm and abroad and his "wooden dummies were called art," his thoughts went to her. "Then she probably was happy about her always-doubtful son," he is supposed to have said.

He could carve as many as three figures a day, so his production was extensive. Many sculptures were lost before Axel Petersson's greatness was discovered, but many have been preserved, and today an excellent collection can be viewed at the "Dödarhultar" museum in Oskarshamn.

Sami woodworking

Tools, household utensils, and other items used by nomadic people needed to be easily transportable. They were made to be light, compact, and versatile enough to be limited to a relatively small number. The objects were skillfully made from natural materials available in the surrounding area using designs that grew out of, and were characterized by, special cultural conditions. This was true of the woodworking of the reindeer-herding Sami. [Editor's note: These indigenous inhabitants of northern Norway, Sweden, and Finland are also known as "Lapps."]

In our times many of the tools that were formerly life necessities have lost their function and significance. Back when those tools were necessary practically every Sami mastered the techniques for creating these objects. Nowadays industry supplies us with finished products instead. This is also the case for the Sami, whose way of life is quickly being changed. In spite of this Sami woodworking has not died out. It is so special and culturally rich that it has survived as art handcraft in its own right.

Nobody knows for certain where the Sami cradle was or how old Sami culture is. But it is certain that they originally lived as hunters and fishers. It wasn't until they had to compete for space on the fields and in the water that they began gathering reindeer and turning what was formerly game into a more or less domesticated animal for herding, milking, and slaughter. This led to the nomadic life of long moves between the reindeer's summer pastureland in the mountainous areas and the winter settlement in the woodlands region.

There are also divided opinions about the origins and cultural background of the characteristic patterns in Sami woodworking. For example, braided band decorations have been found on metal objects from Norway and the Mälar valley of Sweden dating from about the 600s. Today it is almost certain that these ornaments were made by the Sami in the Mälar Valley. But the braided band decoration can also be traced back in time to a location in central Europe, and some people believe that this same type of decoration is found in floor patterns in southeastern Mediterranean countries, among other places. The designs are believed to have spread from there together with Christian teachings. Researchers have found additional connections between the special patterns on the magic drum and patterns found in Southeast Asia.

The magic drum of the Sami people ("Lapps"), the indigenous inhabitants of northern Scandinavia. Used for ritual purposes, it is one of the Sami's magical pieces of equipment. These drums were made from burls on a tree trunk. A piece of reindeer hide decorated with mythological designs was stretched across the top of the drum.

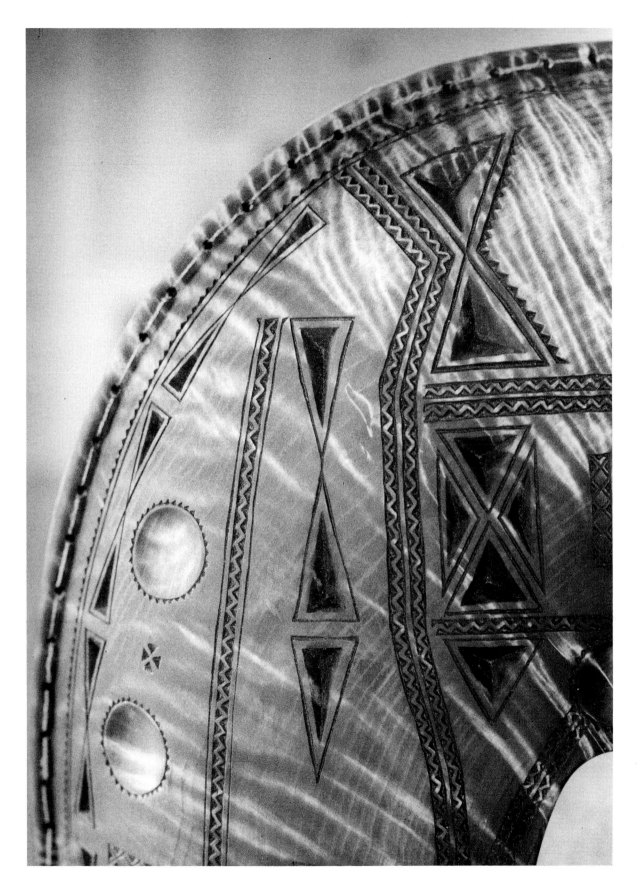

At the same time other connecting links have been found that hint at influences from the north. This northern tradition was probably brought in via trade links from the east. Today Sami woodworking is divided into northern and southern pattern traditions. The northern crafts are mainly decorated in floral-based patterns, along with heart shapes, soft curves, inscribed circles, and crossed loops. The traditional southern pattern is more geometric with surface-covering ornaments, lattice, and zigzag borders.

The patterns carved by modern Sami knife makers and woodworkers are based on traditions with inspiration from the north, east, and south in a handcraft tradition that is still being passed down to new generations.

Materials for Sami handcrafts

The most important materials for Sami handcrafts come from nature and can be divided into two main groups.

The first consists of everything that the woods have to offer in the form of wood, birch bark, and roots. Birch is absolutely the most important kind of wood for the Sami. It is the most useful wood for woodworking, especially in the form of burls (knot-like growths) found on the trunk. Since olden times they have used birch wood for tent frames. The birch bark is used for handcraft purposes and was once used for roofing. Birch, and sometimes spruce, provides the roots used to bind household utensils such as salt bottles, trays, and baskets. Alder and juniper also provide woodworking material. Alder bark is used for coloring handcrafted objects of wood and horn and for tanning reindeer hides.

Reindeer provide the other main group of materials for handcrafts. The Sami get their sewing leather from reindeer hides—both with and without hair. Thanks to the spool shape of the hair

(which creates a layer of air next to the skin) and the air-filled cells inside the hair strands, the hide with hair on it keeps you very warm. In fact, reindeer hide is considered the warmest animal fur. Reindeer sinews are of great importance when sewing the hides because they swell and create a watertight seam when exposed to moisture.

The most well-known handcraft material that comes from the reindeer is the antler. It is above all the large buck's (the bull's) antlers that are used. Well-made Sami knives with both handles and sheaths of reindeer antler—sometimes in combination with other materials—are among the most beautiful Scandinavian handcrafted products you will see.

The Sami also use materials that can't be obtained from their immediate surroundings. Metals, primarily tin, are used in combination with antler and wood in objects such as knife han-

In the Sami household the napie, the milk container, is one of the most important tools. It is used for milking reindeer and has an edge that curves inward at the top to prevent the milk from splashing out. The napie is, like this one, usually made from a burl from the trunk of a birch. Various Sami patterns are often carved into pieces of reindeer antler inset in the wood. They are then colored with the red substance found in alder bark.

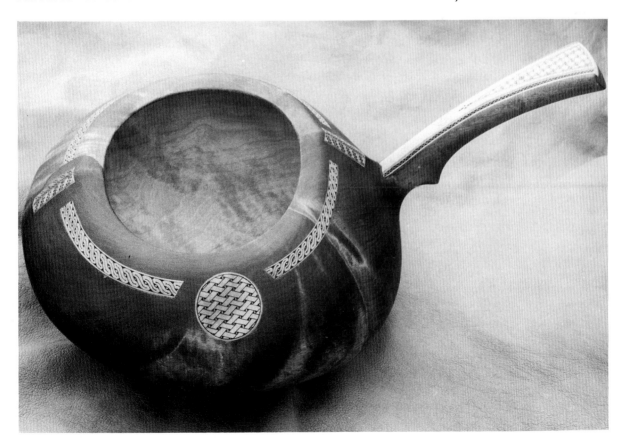

dles, and for tin-thread embroideries on textiles or hide. Textiles are not found in their area either, and must also be obtained from the outside.

Sami woodworking

Sami woodworking is primarily done in curly-grained wood and with burls from tree trunks. The curly-grained wood has irregular growth patterns that cause typical changes in the wood. These are most common in birch, where the entire trunk usually has flames.

(With alder and sallow on the other hand, these patterns usually appear in the root systems.) The burls on the trunk appear as a result of disturbances to the growth pattern of the tree. This beautiful wood has a lively flame pattern.

The burls from the trunk are primarily used for the typical Sami *napie,* the milk container. The napie was used for milking reindeer and was given its inwardly curving upper edge to prevent the milk from spilling out easily. This shape serves a special purpose but is also aesthetically pleasing.

Very large burls from the trunk were used to make the Sami magical drum. This instrument, the *nåiden,* allowed the magician to make contact with supernatural beings. The large burls were hollowed out with various gouges and polished to a perfect surface. The open side was covered with a drum skin, which was decorated with pictures and symbols representing various gods and spirit beings beyond our world of vision.

Native American handcrafts

The Native Americans on the Northwestern coast of the continent developed some of the most complex and distinctive cultures in early North America. Anthropologists have classified six

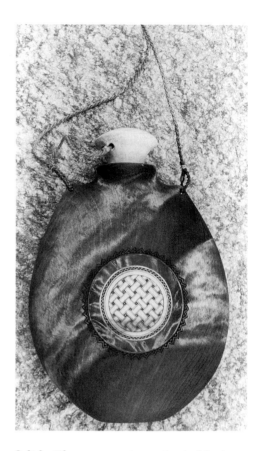

Salt bottles were an important object that burls were used for. In the middle of the side of the bottle a hole was made, which was then covered with an engraved piece of antler. Through this hole and through the opening at the top, the bottle was hollowed out. The string for carrying it is twined out of sinews from a reindeer's back muscle.

different groups on the coast of British Columbia: Haida, Tsimshian, Kwakiutl, Bella Coola, Nootka, and Coastal Salish. Despite great differences between the cultures of the various tribes, all these groups have in common the making and raising of totem poles.

Totem pole is the name that Europeans gave the sculpted wooden poles. The expressions totem and totemism have since also become associated with a wide range of beliefs and customs among various people, and now these expressions are used to describe the symbolic relationship between natural phenomenon and human groups. The basic idea is that different prevailing forces in nature are used to identify differences between people.

This means that the figures on a totem pole are a basic way of expressing belonging to the clan that raised that particular pole. The various figures on these poles are symbols, usually in animal form, that tell of what from mythological times was included in the group. For example some Kwakiutl families promote the thunderbird as their primary totem. It comes from the sky, removes its animal dress, and takes the shape of their human ancestors. Others raise their totem based on the meeting their forefathers had with powerful beings. Especially important were the totem poles raised by descendants of a particular chief to honor him.

The person who ordered a pole certainly discussed what would be in the totem, but the carver was given great freedom regarding the shape. The meaning of each totem pole was very personal, and unfortunately all the detailed information about the meaning of each pole was lost with the people by and for whom it was made. Today we recognize only the basic intentions of these magnificent works.

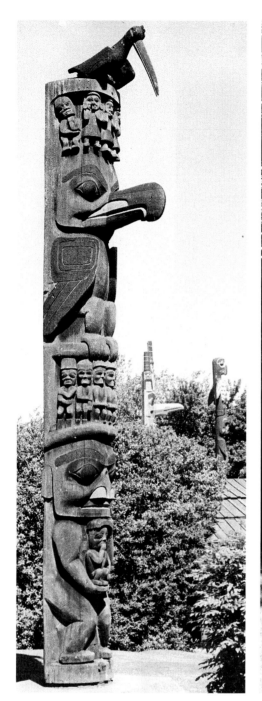

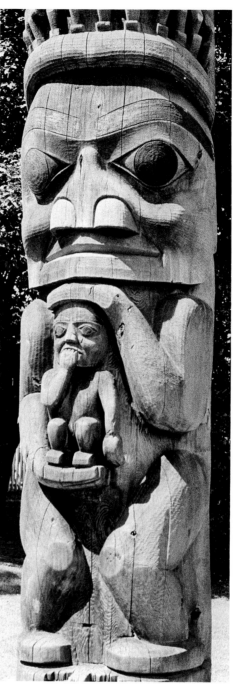

This thick and robust totem pole contains human figures and representatives of the animal kingdom. It is located outside a museum in Victoria.

The old woodcarvings on the west coast of Canada exceed all other wood handcraft work in the American continent. The tight coastal forest offered excellent raw materials for exquisite wooden objects. The handcraft workers got their raw materials for both household and ceremonial

objects there. The types of wood varied, but for totem poles red cedar (which is soft, resistant, and grows straight) was used almost exclusively.

The tool drawer of the totem carver originally included chisels, axes, and knives with blades of stone, bone, and horn, or hard shells. There were drills equipped with bone tips, stone hammers, and wooden wedges. Paintbrushes were made from porcupine quills, and the paint itself was made from pulverized earth pigment mixed with a binding agent such as salmon roe.

Axes and knives in various profiles (and often with double edges) are among the most used tools of the totem carvers. With them it is possible to make cuts with such exactly carved details that polishing is unnecessary.

The metals brought by the white man came to play a significant role in the production of tools in the Northwest. With improved tools came an increase in the production of totem poles, and a peak in artistic development was reached around the middle of the 1800s. Early fur trade with the Europeans suddenly increased the welfare of the Native Americans of the region, which in turn resulted in an increase in the production of masks, ceremonial objects, and more and larger totem poles. This extraordinary heyday of art and culture made the Northwest coast widely known, but it did not last very long. The fur trade dropped off but not before the natives had become dependent on a money-based economy and afflicted with the white man's illnesses.

Privation and death reduced the population to a fourth of its size in just a century. The proud totem poles were left to fall to ruin or become the white man's booty. There were only a couple of Kwakiutl towns in the south where the natives were strong enough to maintain some of their totem production and continued to make fine traditional works.

Since the 1950s, however, a new generation of totem carvers has emerged, and today various poles and other traditional objects based on and inspired by the old culture are carved. Red cedar is still found in large enough dimensions to be the raw material. However, the poles are no longer carved mainly to be put up in the towns as before—now they are made for museums and other cultural institutions instead. The tools have changed to some degree as well, but the work has not been mechanized: carving is still done by hand.

When you enter a totem carver's workshop the fresh smell of green wood hits you. While the large totem poles are naturally carved outdoors,

ceremonial masks and other small objects are made inside the cozy workshop. The sharp double-edged knives cut in a manner that makes finishing with sandpaper completely unnecessary: it would only disturb the exactly carved details.

So one type of handcraft that is among the world's most mystical and well-known has managed to survive and flower again, even if these great monuments will never resume their original significance.

Maori woodcarving

The Maori are considered New Zealand's aboriginal population and are closely related to other groups of people on most other South Sea islands. They are so widespread because the Polynesian people were successful seafarers at certain times, unafraid of stormy seas or of going long distances

The Maori woodcarvers create details with spiral ornaments and toothy coils for architecture and utilitarian objects. Mother-of-pearl plates will probably be placed in the holes that have been carved out of this design.

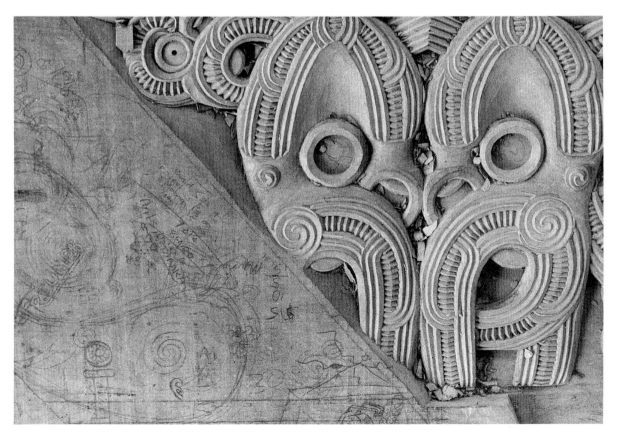

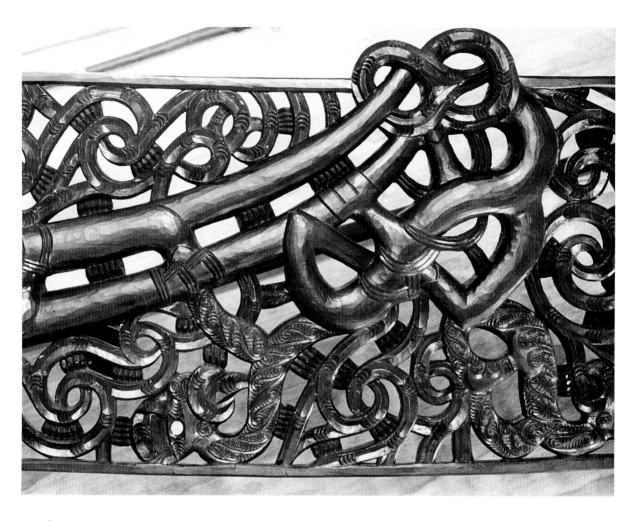

in their canoes. The canoes were of great importance to the lives of the Maori and were the objects of great attention and decoration, often with distinctive latticed carvings in the magnificent bows and sterns. They were mainly decorated with spiral ornaments but also with human figures similar to the body statues and face statues for which the Maori are so well-known. Some of the carving on their ships actually resembles what we see on Viking ships, without the two cultures having had any connections at all.

It was not only canoes that they decorated: they used the same techniques on their wooden

There are also strong latticed shapes with very complicated coils and spirals.

homes with high roofs and open verandas. The same ornaments also appear on trunks, weapons, and certain important household articles, and they can be considered a very typical distinguishing feature of Maori decorative art. The typical New Zealand "demon" style comes from combining spiral ornamentation with human forms. These spiral coils seem to threaten to take over all of these figures.

With all due respect to music, dance, and other expressions of culture, the most marked cultural inheritance of the Maori is undoubtedly carving. The primary material is wood, but bone and stone are also used. Old objects have been preserved, including objects from the very first century of Maori settlement in New Zealand.

How did these traditions arise? Here, just as in many other places they are related to mythology and religion. Legend tells that carving was the invention of the gods and unknown among people until the god of the sea, Tangaroa, kidnapped the son of the mythical hero Rua. Rua, who was a courageous man, went off to look for his son and found Tangaroa's richly sculpted dwelling. There he was successful in stealing a number of carvings to copy for his own home. According to legend, this is the reason for the rich and well-developed carving found on New Zealand far back into history.

Today the Maori are a minority population in New Zealand, but they have nevertheless succeeded in preserving their distinctive character and their decorative techniques. There is a well-known cultural center at Rotorua on New Zealand's northern island where the old wood-carving traditions are practiced and attempts are made to pass them on to the future generations.

Woodcarving on Bali

In Indonesia woodcarving is done on most islands. Bali occupies a special position because its town of Mas, just north of the capital, Denpasar, is the center for Balinese woodcarving. Previously a separate kingdom, Mas today has up to 8,000 inhabitants who all have something to do with woodcarving. In Mas, as in most other handcraft towns, the established masters gather groups of students around themselves and produce carvings through an excellent system of teaching and labor.

A group works under the shade of a roof: the old master teacher and young people down to 10 years of age who handle tools and wood with astonishing skill. Actually, these young boys have had several years of experience carving by their fathers' sides and have been trained from the beginning, more or less in play.

The work pavilion usually consists of a bamboo structure with walls of braided bamboo mats and a roof of grass. The floor is cement or tile and is also covered with bamboo mats of the finest weave. Because the wood has to be kept moist all the time to keep it as easy to work as possible, there is often a pond near the workshop. There sunken logs are kept among water lilies and fish who dart aside in fright when a piece of wood is moved.

Work begins early at the workshop. Already at seven the workers are in place, usually after having spent a couple of hours out in the rice field. The mats are rolled out on the floor, the coffee is warmed up, and the tools are honed. Soon the sound of pounding mallets is heard. It seems that the work is done somewhat uniformly in a type of assembly-line process. The masters sketch out the figures, and the youngest students hack them out in rough form. The masters take over again to carve the important details and finish with the fine decorations.

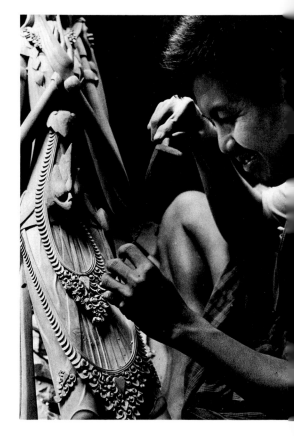

One of the true masters at work. With careful chisel chops he makes the elegant decorations on this goddess carved from light hibiscus. Soon the women will take over and trim and polish without disturbing the fine details.

The sculpture has been laid down for trimming and polishing. The man seems to be almost alive even though he is made of wood. All of the details are exact: the nails, the ribs, the veins in the arms, and the wrinkles in the forehead between the worried eyes, even the braiding in the hat and bag which were also carved out of the same piece of wood.

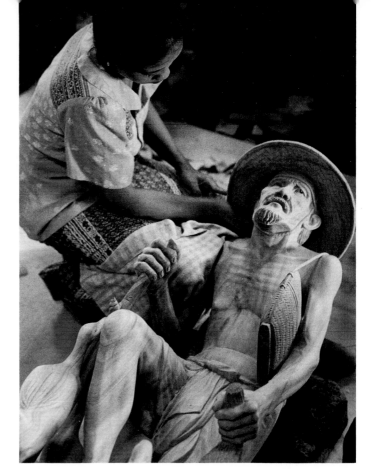

The motif for these carvings often comes from Balinese mythology, just as when bone or stone is used. The figures include symbols for good and evil from Balinese dances, such as the large fantasy bird Garuda, Rwana (the symbol for evil), and the hero Rama with his beautiful wife, Sita. There are numerous other mythological figures, all with fantasy-filled characteristics. Some of the figures come from daily life: from work in the rice fields or from cock fighting with the striving cocks.

Traditionally it has been possible to divide Balinese carving into three different groups. The first group is the traditional decorative carving with figures inspired by the Sanskrit epics *Mahabharata* and *Ramayana*. The second consists of carved masks for the various traditional dances, which are built on old Sanskrit poetry. These masks are usually carved in softer types of wood, painted in clear colors, and decorated with such materials as wild boar

tusks, horsehair, and finch fibers. The third group covers modern carvings with a pure and simplified style that lacks the many details of traditional carving but shows a refined play in its lines. In recent years a fourth group has come into existence for the sake of the tourists. These are mainly birds carved in soft wood then painted and lacquered.

The tools used are of the very simplest type. The first rough shaping is usually done with an ax. There are two kinds, the same type we are used to seeing and one with a significantly longer blade. They are both only sharpened on one side (usually the left), which means that very fine shavings can be removed. The chisels are actually nothing more than an iron pin with an edge on one end and no shoulders on the blade. This makes the chisels incredibly flexible, but also very weak. For this reason the handles on the most delicate chisels are forged in a spiral shape to make them a little stiffer. Chisels from only a tenth of an inch (a few millimeters) to a couple of inches (several centimeters) wide are used. They can be straight, slanting, or curved with the bevel on the concave side. Both straight and curved knives are used. The mallets are simply a head with a handle that is crosswise to it and are made of ebony or some other type of hard wood.

After weeks or even months the figures take on more and more of a shape. With careful chisel chops the wood is removed piece by piece. The carvers alternate between chisels of various widths, study the relief, and adjust until they are completely satisfied. Then it is time for the women to do their job. This consists of trimming and polishing, of very patiently giving the figures their finish without disturbing the contours or fine details. They also do decorative carving of very intricate figures to complete the work after trimming.

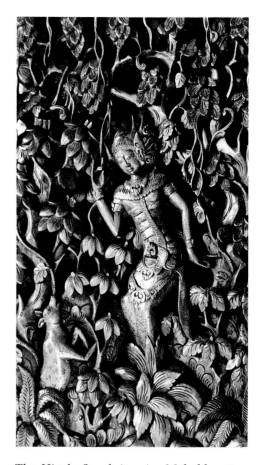

The Hindu Sanskrit epics *Mahabharata* and *Ramayana* are often the basis for Balinese woodcarving. This relief tells the legend of the beautiful Sita and the roe deer.

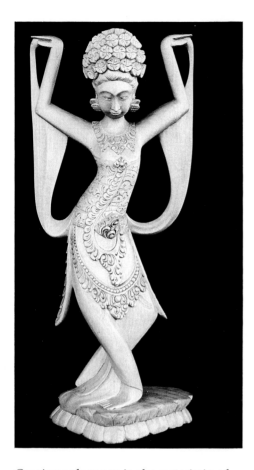

Gracious elegance is characteristic of Balinese carvings. This dancer is an example of that: she seems to float in the air with soft elegance and with perfect harmony in the lines.

The types of wood used are usually hard and difficult to work: mainly imported ebony from the large islands of Borneo and Sulavesi, but local wood such as hibiscus is used too. For masks and other figures that are to be painted, softer types of wood are usually used. But despite access to local wood (which is often more easily worked), reddish black ebony appears to be the absolute favorite of most woodcarvers. Perhaps using the hard and difficult-to-work types of wood gives a higher status.

Naturally there is better and worse Balinese woodcarving, but you will find hardly any bad work. Some carvers have discovered that it is easy to do business at the tourists' Sanur Beach and that far from all of these tourists view their work critically enough to determine whether it is good or not quite so good. So now many figures are less detailed, are not trimmed, and are perhaps not polished either. On the other hand the great masters stick to traditional ways of working and finishing, and in the products made by them and their students you can really see pride in workmanship and knowledge of artistic handcraft.

Makonde carvers in East Africa

"In the bush not far from a river a man lived like a wild pig. Because he grew tired of loneliness, he sculpted a woman from a tree trunk. He had children with her. The first one was born near the river and the second a little further inland. They both died at birth. The third child was born up on the high plateau and survived. After this Makonde settled up there." This is, in essence, the Makonde tribe's myth of creation, recorded sometime near the turn of the century and still told. From this old story we can discover both the reason for the great importance of sculpture among the Makonde and hints of the structure of the ancient, family-based

culture where wooden statues with female shapes often show the origins of the various family groups.

The high plateau they speak of is the Mueda plateau in northern Mozambique on the border with Tanzania (then Tanganyika). The tribal designation Makonde has been traced to the words for "high plateau" and "fertile soil." The Makonde probably descended from another group called Matambwe but changed names when moving to the more permanent residence at Mueda, possibly to mark a new lifestyle and a clear cultural change.

Up in the Mueda plateau the Makonde lived fairly isolated from other groups and in peace from both the slave trade and Christian missionary work. The first Christian station did not appear there until the middle of the 1920s. Because of this the Makonde on the Mueda plateau were able to preserve their distinctive character far into the 1900s.

Another group of Makonde developed their own culture and lifestyle somewhat further north on the Tanganyika side. This culture soon felt the effects of political and cultural disturbances, and most of the old traditions disappeared, even woodcarving.

Economic development in Tanganyika caused more and more Makonde to move from Mozambique across the border to the north, and by the middle of the 1900s this migration became extensive.

In all historic cultures, art and handcrafts have been of great significance to religious rites and to ceremonies meant to strengthen magical powers. Wooden sculptures belong to the means of expression that help call forth the spirits of the forefathers and the supernatural powers that are necessary for successfully carrying out these rites. These were the religious and social ceremonies that caused the Makonde art, particularly woodcarving,

Right: The Ujamaa figures are a type of totem built on ancient African family traditions. This ebony wood trunk, filled with carved human figures, has kept its light outer layer.

Far right: A Sheanti, which is Swahili for devil. It appears often in folk traditions and can stand for several different beings. Some eat up what people have planted, others take fish from the river, and some live off the prostitutes. The Ujamaa and Sheanti styles are both modern types of Makonde woodworking, and in recent years they have become the most popular and widespread.

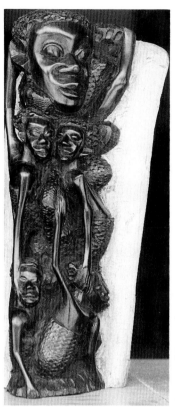
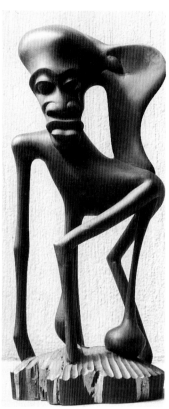

to be developed to an almost extravagant level.

In addition to the female statues symbolizing the origins of different tribes, there were also masks of various types in the early sculptural art of the Makonde.

As Africa became colonized the woodcarving of the Makonde became influenced by commercial interests. Workshops for mass production were started and developed along with the traditional carving. The result was that more and more products were adjusted to the European market. These included various animal figures like snakes, hippopotamuses, and crocodiles. Figures were usually carved in light, soft wood and painted in red and black geometric patterns. Utilitarian items were another branch of carving: mainly spoons, ladles, plates, and wooden mortars. These also had geometric decorations. Later some furniture production came into the picture.

During the 1940s Makonde carvers gained some professional status as the artists became affiliated with various authorities and institutions. These artists, while certainly forced to produce according to demand, succeeded in preserving and developing their aesthetic style. The marketing opportunities that now opened up to them also made it possible for them to preserve the integrity of their art. In fact, they sometimes even produced caricatures of well-known personalities in the colonial hierarchy.

It was about this time that the choice of materials changed. After formerly having worked primarily with soft types of wood, the carvers switched to more and more ebony, a change made possible by access to modern tools.

There were still carvers who regarded their creative work as a connection between humans and other parts of nature. But the artists' sculptures were separate from nature by being abstract expressions rather than simple realism. Modern Makonde sculptures (primarily from the early 1950s onwards) should be viewed in this light.

In the late 1950s a new style emerged, this time with a carver named Samaki as the main person. He made a Sheanti, which is Swahili for devil. It is a figure that appears in the oral folklore traditions.

Sheanti can stand for several different beings with their own names and their own abodes. Some live on the savanna, others in the bush. Some eat up what people have planted, others take fish from the river, and there are even those who live off the prostitutes.

The stories about the Sheanti, like so many other traditional stories, help humans overcome the difficulties they encounter, while stimulating fantasy. However, there was no opportunity to develop the Sheanti style in Mozambique, because of the strong position of the Catholic church there. In Tanzania, where the picture was somewhat different and more liberal, the Sheanti style was developed to perfection.

One additional style, the Ujamaa, emerged in Tanzania in the 1960s among the Makonde carvers who fled Mozambique. It is a type of totem built on the old African family tradition. It is carved from a massive trunk and filled with human figures with typical Makonde characteristics.

The development of various styles by the Makonde is not over yet. There is a bottomless source to draw from for these fantastic carvers. Everyday fears about water shortages and political problems as well as symbols of fertility and love are among the things that inspire today's Makonde artists.

When we visited a group of woodcarvers right outside of the Tanzanian port city of Dar es Salaam, they showed their dynamic view of the work. The ebony trunks were worked with mallets and chisels. Files and rasps had been added as supplemental tools, and sandpaper was used for trimming and polishing. In short, all the modern hand tools were given a place in this contemporary branch of sculpting with traditions and origins in an ancient culture based on one man who lived alone in the bush and the woman he sculpted from a tree trunk.

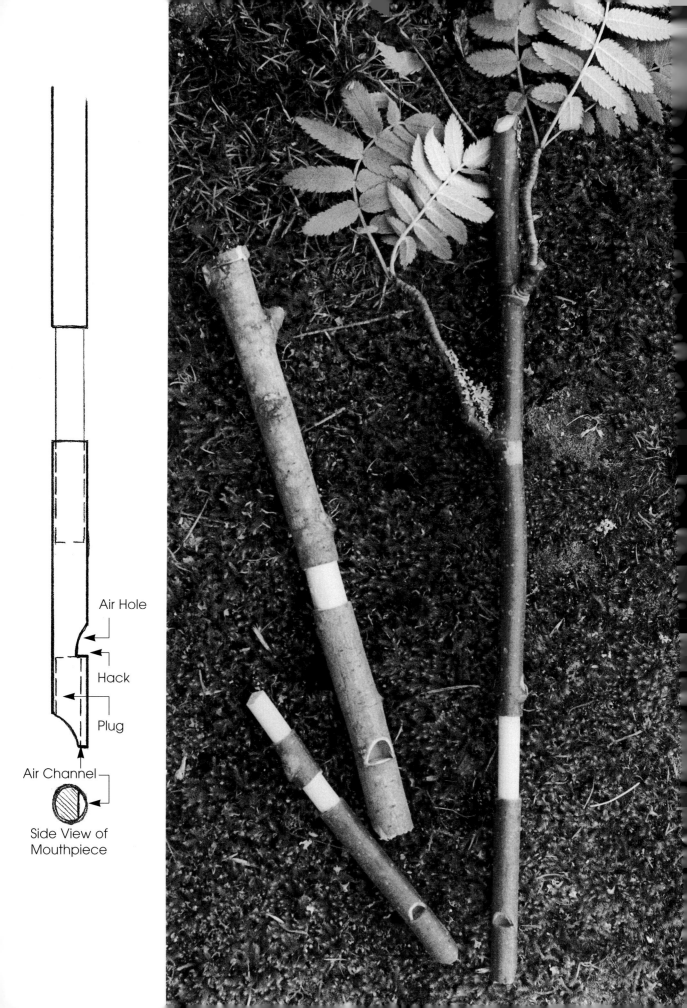

Air Hole

Hack

Plug

Air Channel

Side View of
Mouthpiece

Carving Green Wood

In the spring, when the sap rises, mountain ash and sallow branches are excellent for carving slide whistles. Cut the mouth end at an angle or somewhat inward curve on the bottom side. Now make a ¾-inch/2cm perpendicular cut, a "hack," into what will be the whistle's upper side, 1 to 1½ inches/2½ to 4 cm up from the mouth end. Cut just through the bark to the wood in the middle 4 to 6 inches/½ to 2½ cm from the mouth end. Loosen the bark by tapping it lightly with a knife handle and remove the bark tube. Cut off the wooden stick (that has no bark on it) directly behind where the perpendicular "hack" marked the wood. Carve this short piece of barkless wood on its top side so that an air channel is formed when this "plug" is placed back into the hollow bark tube at the mouthpiece. Thread the pieces back together according to the sketch and the whistle will work.

You can work with either green or dry wood. The prerequisites and the techniques are somewhat different for each. In green woodworking you generally start with the material you find, and the way the wood grows and other natural properties of the wood control the work to some extent. In addition, with green woodworking it's extremely difficult to glue pieces together into larger shapes.

That all wood shrinks and shifts when it dries is another factor to consider when carving green wood. And it shrinks differently lengthwise, radially, and tangentially, further complicating green woodworking. Lengthwise shrinkage is insignificant: only about 0.1 percent. Radially the wood shrinks about 5 percent and tangentially about 10 percent. This can cause the wood to distort as it dries. Therefore it is absolutely necessary to cleave logs in the middle and not use a piece of wood that extends across both sides of the pith. Using such a piece would cause the object to crack.

The primary advantage of carving green wood is that you use the material when it is softer and easier to work than after it has dried. Cutting green wood requires significantly less strength than cutting into dry wood. In addition you can work with slightly sharper edge angles, which is actually required in some types of fibrous wood like sallow. In some cases, it may be necessary to do the final working of the surface after the object has dried, and you *must* wait until it has properly dried if you want to polish your carved product smooth.

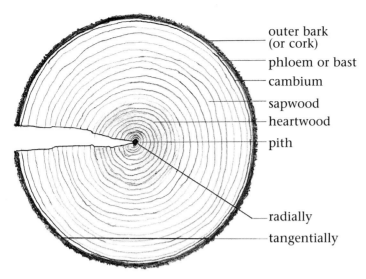

- outer bark (or cork)
- phloem or bast
- cambium
- sapwood
- heartwood
- pith

- radially
- tangentially

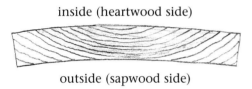

inside (heartwood side)

outside (sapwood side)

Because wood shrinks approximately twice as much in the tangential direction as in the radial direction, most wood splits when drying as logs. Certain types of wood, such as alder and birch, are less likely to crack and in favorable circumstances can be dried as logs. A good way to keep cracks from forming is to always cleave the wood through the pith before drying.

Shrinking conditions in various directions of the grain cause boards that do not come from the absolute center of the log to warp with the heartwood side upwards when drying.

It is wonderful to work with green wood outside where the presence of nature is inspiring. Taking a few tools along into the woods is not a problem. Axes, knives, a few gouges and chisels, and perhaps a bent carving knife are what are needed. On the other hand, without the clamping devices found on a workbench it's necessary to use your hands and feet to help hold objects in place. A carving bench [Editors note: sometimes called a shaving horse; see page 62 for photographs] is also an excellent alternative. One can be made by several methods, but the principle is that a "lattice" or "head" attached to a pedal holds the workpiece in place while it is being worked on.

A thick plank, a log, or a special chopping block is also a good device to have handy when hollowing out bowls and troughs with the help of an adze.

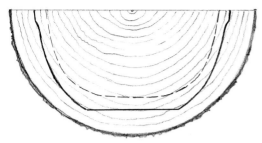

A bowl that is carved from green wood with the opening on the heart-wood side curves as shown in the sketch as the material dries.

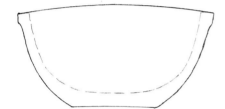

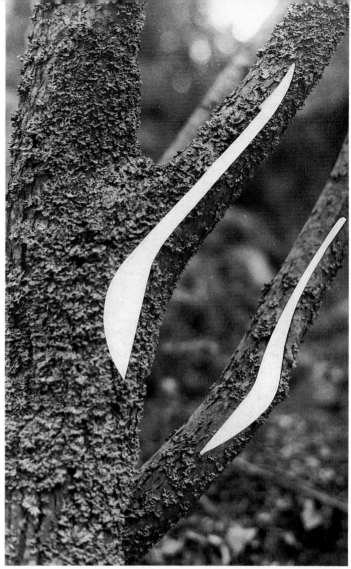

Utilize natural shapes so that the form of the object follows the direction of the grain. The curve where a branch is attached, a crooked branch, or a bend that is often found near the end of the tree with the roots are all excellent for this purpose.

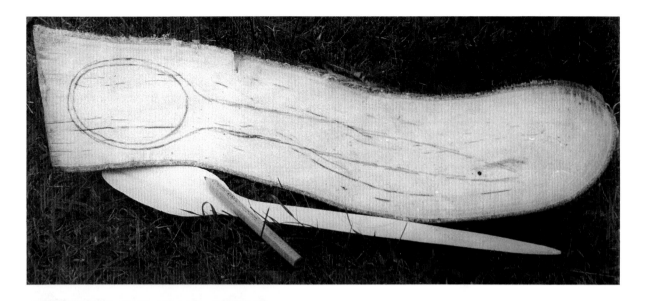

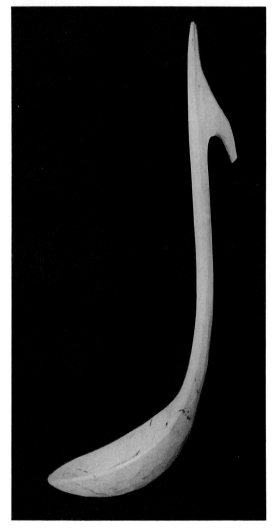

After the crooked part of the wood is split in the middle the model is sketched on it and the work of the ax, knife, and gouge can begin.

This finished ladle has been shaped according to the curve in the trunk, but after drying it curves more noticeably due to movement of the wood during the drying process. If the ladle had been made from the inner curve of the trunk instead, the relationship would have been the opposite.

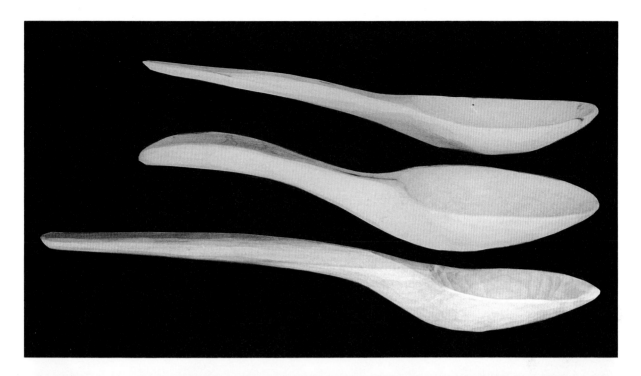

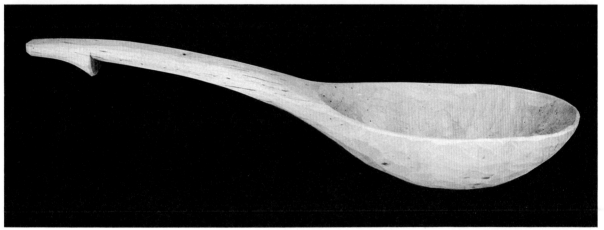

Top: Because these small spoons (made out of green ash and birch) were not carved out of curved sections of the plant, the lower part of the handle on each has been made somewhat broader to withstand the pressure that comes at that point.

Bottom: Rough ladle carved from green birch. There has not been any finishing; instead, the rough cuts have been allowed to remain.

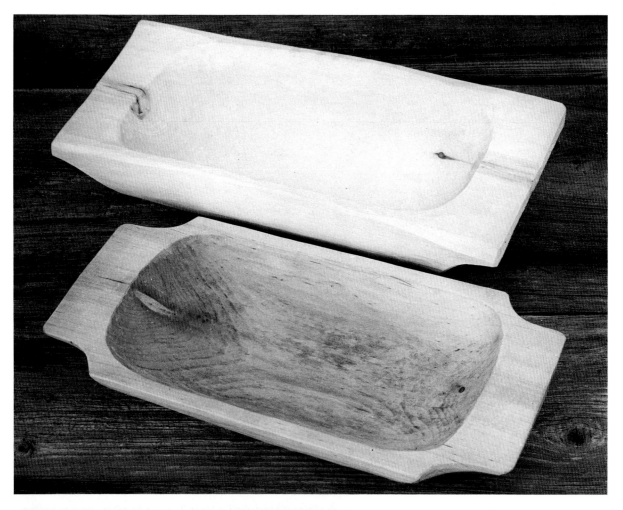

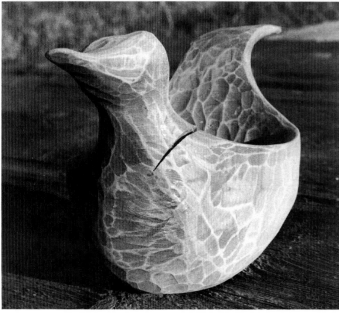

Two green-cut small troughs in ash and birch. They have both been carved out of half a log; the pith was just outside the upper edges of the trough.

An example of what happens when the pith of the trunk is included in a wooden object. As a result of the tension that occurs around the midpoint of the drying trunk, the wood cracks.

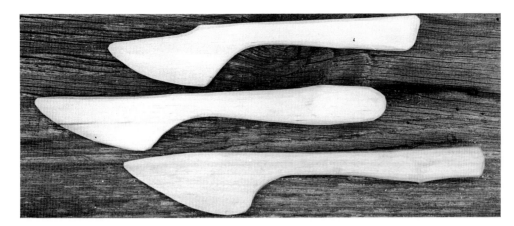

Pieces of wood left from making larger and thicker objects can be turned into butter knives.

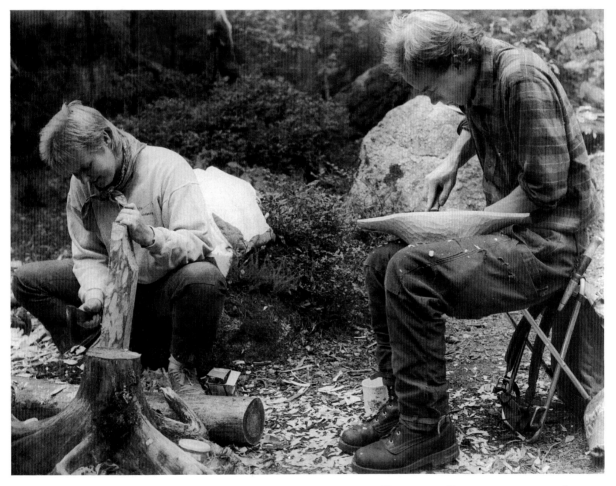

You can easily carve green wood outside using an old stump as a chopping block. Working with a gouge can be done while holding the dish tightly between your knees.

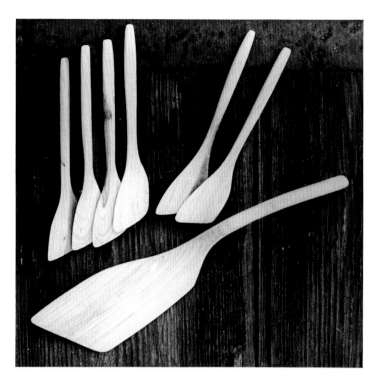

Cake servers and small cake spoons gently shaped and polished smooth after drying. The material is mountain ash, which is a hard and tough wood.

Spatulas, below, are among the objects that do not require large-sized starting materials. They can also be whittled out of the leftover pieces of wood that remain at the chopping block.

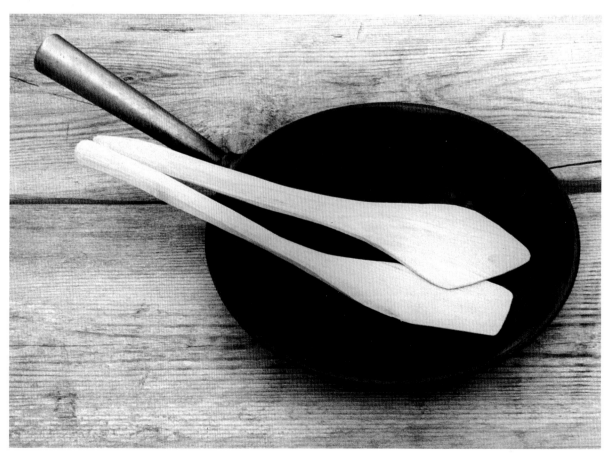

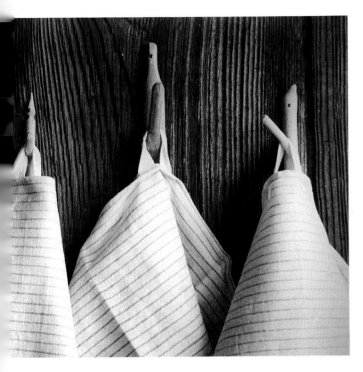

Branch "oarlocks" that are left after
the trunk is trimmed can be made
into simple hooks and hangers. Holes
are drilled toward the top and bottom
for attaching them.

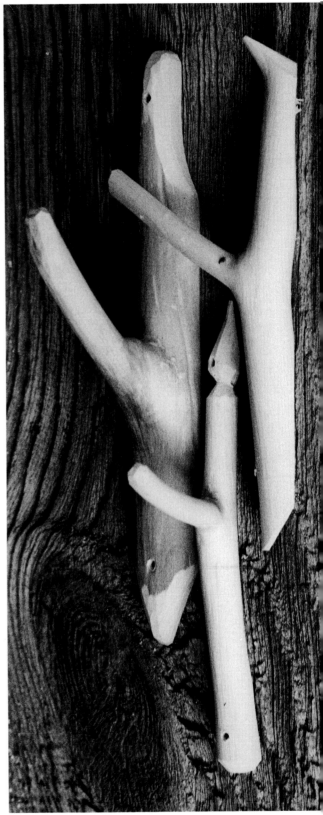

A professional woodworker carves a spoon

Woodworking is done under a variety of conditions using various tools and techniques. This sometimes, but not always, affects the results.

In school woodworking there is usually one way of doing things. The workpiece has to be attached, the tools have to be selected to fit function and safety concerns, and the wood is usually chosen based on the school's requirements. Hobby woodworkers have other methods of working. They may not have all the tools necessary, and they may not have the ideal workshop. The professional woodworker, who is to earn a living from his or her handwork, has other requirements. The tools and other equipment have to be suitable for sensible woodworking, the material has to be first class, and the technique must be nearly perfect.

There are not many professional woodworkers today who make spoons and ladles, but we met the woodcarver Edvin Karlsson in Hästmahult, Sweden. The photo series shows how he creates a spoon from a green piece of birch using simple but functional tools and a system that he developed after several years of work.

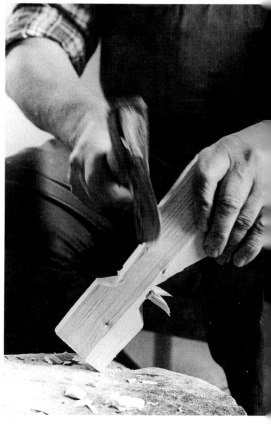

1. When this professional makes a spoon the green piece of birch is shaped with the help of an ax while being supported by a chopping block.

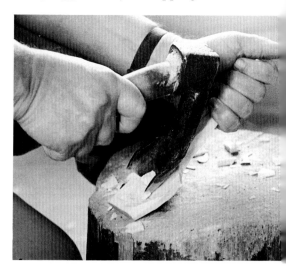

2. The inside is roughly shaped with an adze while the ladle is held against the chopping block with his hand.

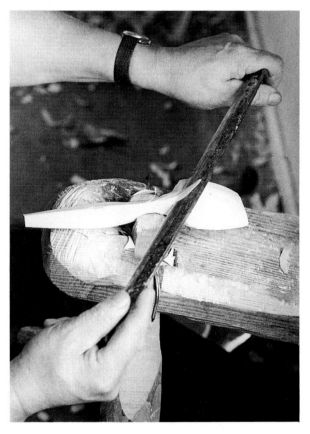

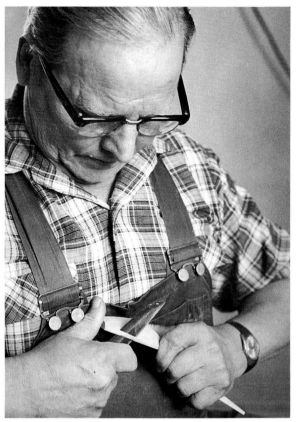

3. The spoon is attached to the carving bench and details on the outside are fine-tuned with a drawknife.

5. The final adjustments, so that the spoon's thickness is consistent and its edges are even, are made with a carving knife.

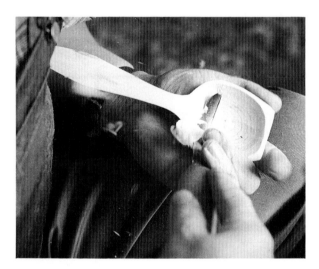

4. The inside is carved clean with a bent carving knife.

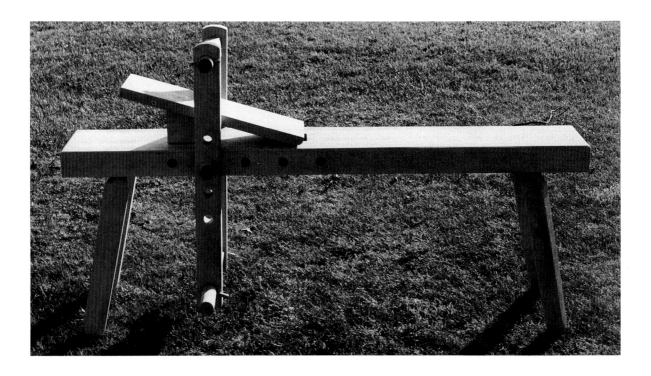

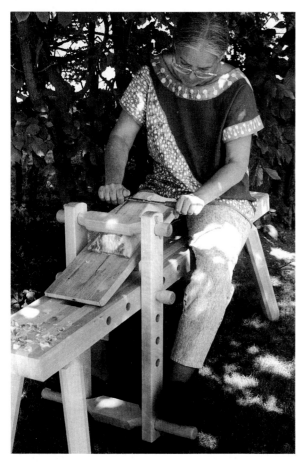

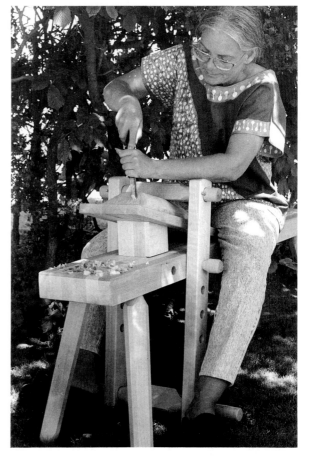

The carving bench

1. The carving bench [or shaving horse] is a good old design that in certain ways is even better than the carpenter's bench as far as holding objects in place is concerned. Above all it is significantly quicker to change the hold. Objects are usually attached to a base with what's called a "lattice." Because the lattice can be adjusted both lengthwise and crosswise there are many possible variations.

2. The inclined plane on the bench makes it possible to work the wood in several different ways. Here the work plane leans down and away from the woodworker, which is suitable for activities such as using a drawknife to cut the bottom of a bowl. The object is clamped in place by pressing the pedal of the lattice away from yourself with your foot.

3. If you want to work with a chisel or gouge, it is appropriate to have the plane leaning toward yourself. Then the object is held tightly by pressing the pedal of the "lattice" toward yourself with your heel.

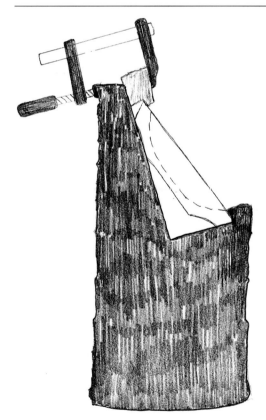

In hollowing out rough bowls and troughs it helps to attach the object to something that leans. This makes it easier to reach and to get the proper angle with the adze.

You can lean the object against a log or rough plank, or a special chopping block (as shown here). The clamp must be placed so that it is out of the way of the edge of the adze.

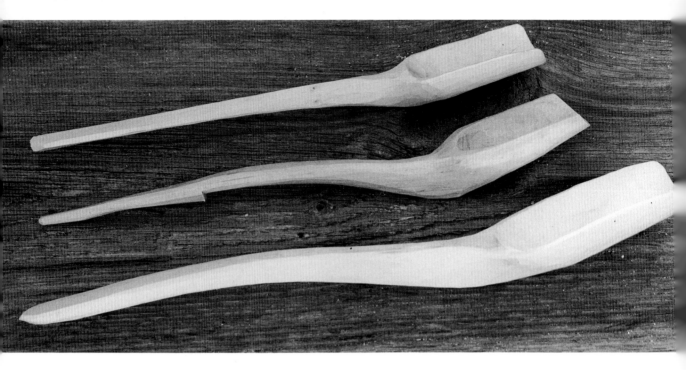

Long-handled ladles with open front edges. A slight curve in the handle creates an angle that makes the ladle easy to use.

Carving open ladles

1. After making a light sketch of the ladle on the green wood, roughly shape it against the chopping block with the help of an ax.

2. At the carving bench the outside of the ladle is given its approximate shape with a push knife.

3. With the material tightly attached to the carving bench, the inside of the scoop can be shaped with a gouge.

4. Another method is to hold the ladle's handle and use the chopping block for support while the inside of the scoop is being shaped.

5. Somewhat more exact shaping can be done by gripping while you partially cut across the grain. The gouge or chisel is operated by twisting the handle. Have both hands resting against the lower surface to get a stable grip and to avoid slipping.

6. Another tool that can be advantageous when hollowing out the inside of smaller objects is a scorp.

7. After the inside is hollowed out, the outside should be trimmed to the exact thickness and shape desired. A good way to do this is by cutting toward yourself. The hand holding the spoon can help you by pushing on the knife with a couple of fingers, but the main force of the cut comes from the finger movements of the knife hand.

8. Another method that can be used is to cut toward the thumb. The fingers of the other hand can push while the knife hand controls so the force of the cut towards the thumb will not be too hard.

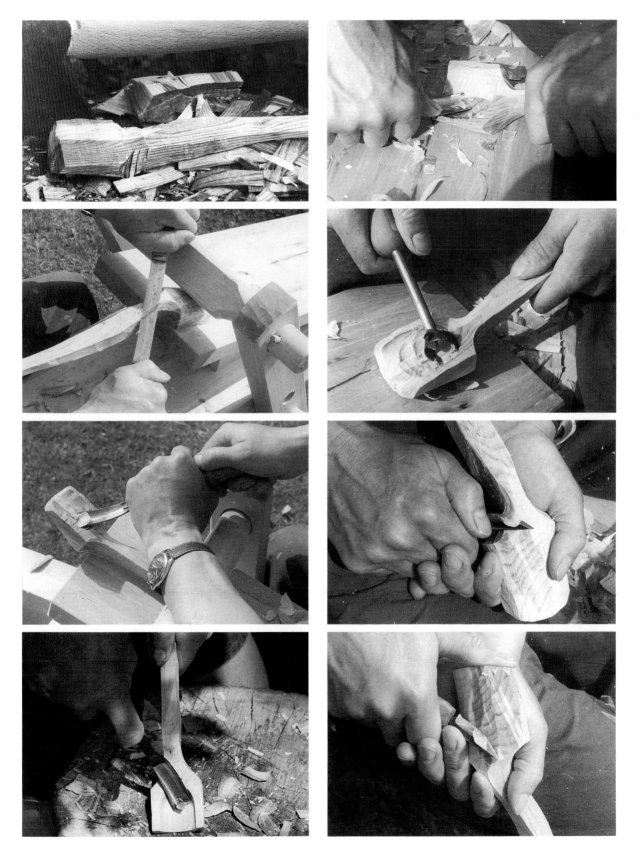

Hacking out troughs from green wood

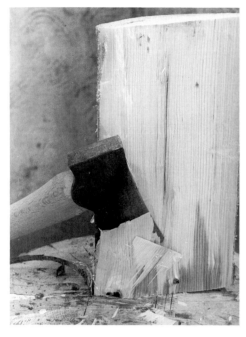

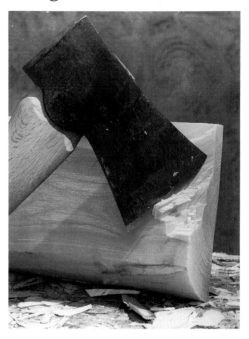

1. The green wood is split off a log. Then the cleaved surface is evened out with an adze.

3. The ends of the bottom of the bowl are roughly shaped.

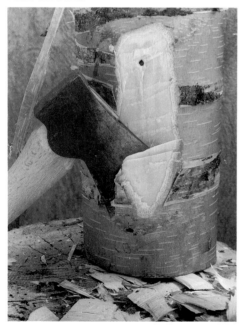

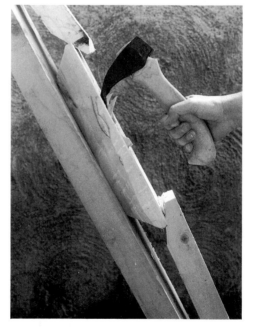

2. On the other side the bottom of the bowl is chopped even.

4. With the object leaning against a slanting surface the inside is roughly formed with the help of an adze.

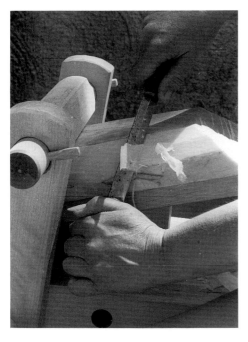

5. The bowl is placed on the carving bench and the long outside sides are shaped with a Swedish push knife.

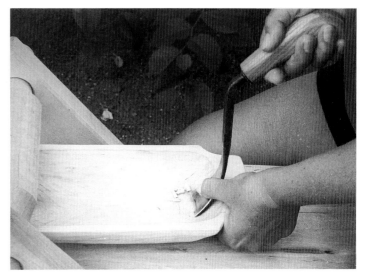

7. The inside is shaped with a *tråglopare* [a "trough runner"] or a curved gouge. Both need blades with a very wide radius so that the surface will be as even as possible. This job can wait until the object has dried.

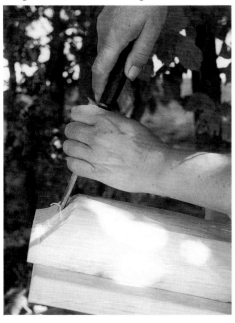

6. The ends are cut into a slightly cupped shape.

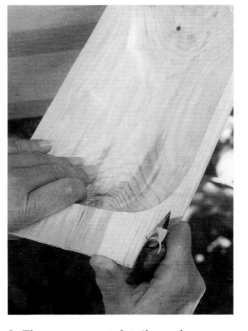

The finished bowl can be seen on page 56.

8. The more exact details, such as carving of the edges of the bowl, are best made with a knife. This can also wait until the object has dried.

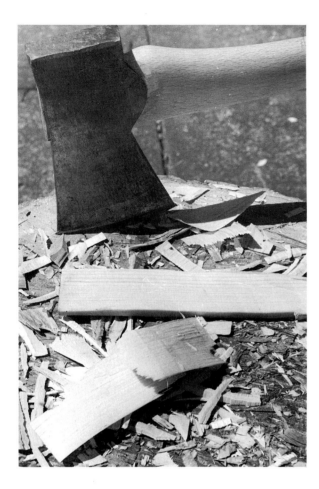

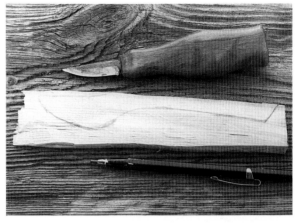

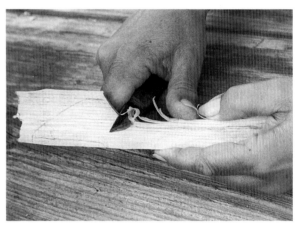

Butter knife

1. The waste pieces that gather around the chopping block can be used to make a variety of wooden objects, including butter knives. Sometimes it helps to trim the wood scrap a little before working on it.

2. After the model is sketched onto the workpiece the knife is the only tool needed.

3 and 4. The curves of the butter knife's underside and the front part of the upper edge are cut by pulling the carving knife toward the thumb of the hand that is holding the carving knife.

5 and 6. The front edge of the butter knife and the handle's end surface are cut out in the same manner but while holding the knife from the other side. Always cut in the direction of the grain, that is, in the "downhill slope."

7. The lower edge of the butter knife's blade probably needs to be made thinner. This can be done by turning the knife away from yourself (as shown here) or toward the thumb.

8. After the edges of the butter knife are rounded with some slight cuts, the final result can be admired.

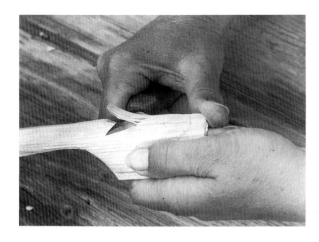
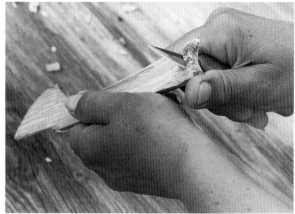
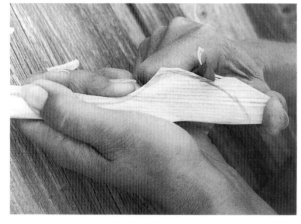
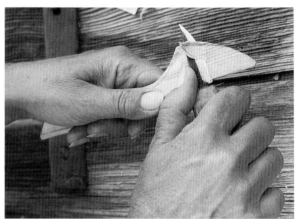
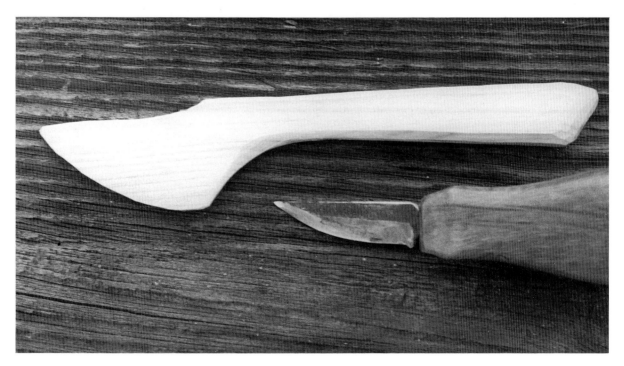

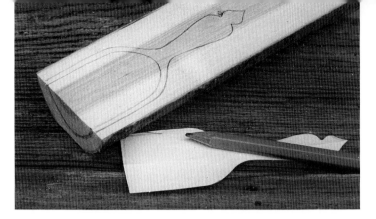

A small scoop carved at a carpenter's bench

Rounded wood can also be worked green at home in the carpenter's shop or the woodworking room. One way of keeping the wood from drying out during that time is to keep it in a closed plastic bag. However, this may cause the material to mold. If you want to be on the safe side, and the workpiece is not too large, you can put the plastic bag with the green wood in the freezer. There it will avoid all attacks and be preserved for a very long time. And it doesn't need to be defrosted before being worked: frozen wood is extremely soft and manageable.

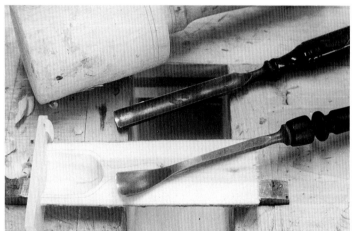

1. The log is cleaved in the middle, and an outline of the scoop is sketched on as shown in the photograph. If you want the handle to rise up somewhat, saw the wood to the desired shape. In order to get the curved wood to lie flat on the bench, it should be planed on the underside.

2. Place a protective piece between the bench stop and the workpiece and attach it. Hollow out the bowl of the scoop with the help of various gouges.

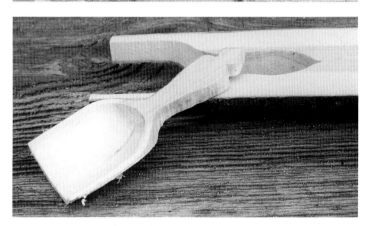

3 and 4. The scoop is sawed out and then shaped with a knife.

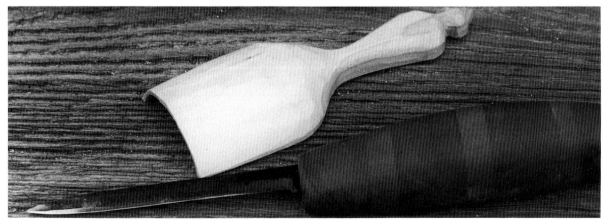

Hollowing out curved ladles at the carpenter's bench

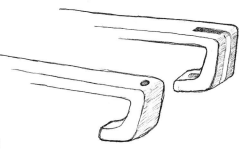

To strengthen narrow ladle handles, drill in dowels or saw in wood strengtheners that go across the direction of the grain.

Even if you don't have access to curved and naturally shaped materials, you should not be scared away from shaping your own spoons and ladles. Just make sure that the areas where the pressure will be the greatest are oversized somewhat or strengthened, either with dowels that have been drilled into place or with sawed-in strengtheners going across the direction of the grain.

1. Following a sketched model, the profile of a curved ladle is sawed out of a piece of wood that is thick enough to accommodate the width of the ladle. Make sure the direction of the grain is along the handle as much as possible. This will make the handle durable, and it will be easier to hollow out the inside of the ladle's bowl.

2. A sketch of the ladle as seen from above. The wood is attached to a carpenter's bench and hollowed out with the help of various gouges before it is sawed out.

3. After the inside is hollowed out, the ladle is sawed out and the bowl part of the ladle is shaped with a wood chisel. Put a protective piece between the workpiece and the carpenter's bench.

4. The final woodworking takes place with the help of a knife.

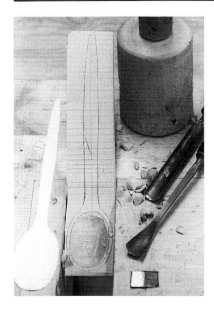

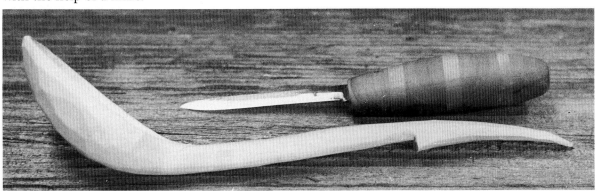

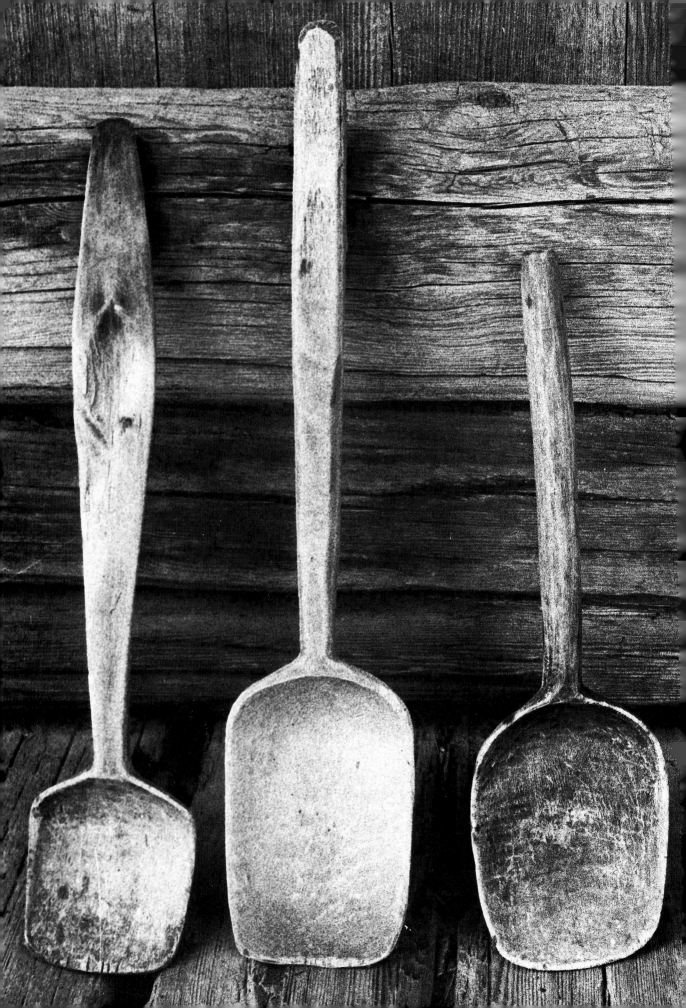

Spoons, Ladles, Kåsas, and Scoops

Three ladles used in farm kitchens to stir the pot and possibly to scoop porridge into the common food bowl before the meal.

Food utensils of rust-resistant steel or silver, ladles and scoops of plastic, and porcelain cups. Today we take these for granted as part of most households. However, not so long ago these and other tools were made completely of wood. The spoon has been around since prehistoric times, while the combination of knife, fork and spoon is a significantly later invention. In Sweden, there was a time when the family's wooden spoons were stored on a special shelf (a spoon rack), where each member of the family placed their spoon after having licked it a little extra after the meal. If you went to visit someone, you couldn't count on the hosts having enough spoons for their guests, so you took your own spoon along.

Spoons, usually with engraved, carved, or painted decorations, once played a great role in courting in certain parts of Sweden. The spoons were carved by young boys and given to the girls they were interested in as a way of showing their interest and finding out if it was mutual. A popular and well-courted girl could gather a considerable collection of beautiful spoons in this manner.

However spoon-shaped tools were not only eating utensils. Variations served a number of different purposes. Ladles for stirring and scoops for scooping milk, flour, salt, and grain were also important. Some had curved handles; others were almost straight. Some were bowl-shaped at the front; others were open like scoops.

Tin and silver drinking cups belonged to the fine people. The peasants in the country and lumbermen out in the log shacks made their own drink-

After the meal the household spoons were placed on the spoon rack where they hung until the next time they were to be used.

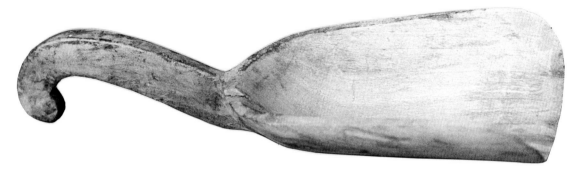

ing vessels in the form of a *kåsa*. Originally, the name *kåsa* referred to a large vessel with handles on both sides. This mug was supposed to hold enough to "go the round." This meant it was necessary to not drink too much so that there was enough for everyone, enough to go *laget om* [the round]. The Scandinavian word *lagom* [just enough] comes from this.

But there are also smaller drinking vessels. These include what we call a *kåsa* today, a one-handled vessel intended for just one person.

For the most part, wooden household items have lost their importance, but they can still be found. Wooden flatware in various shapes is often used to create a rustic and pleasant impression, and coffee still tastes good when you drink it out in the woods from a wooden *kåsa*.

Slender little scoop with a beautiful handle. This was probably not used for any coarse goods. It was more likely to have been used for something like scooping flour from the bin.

74

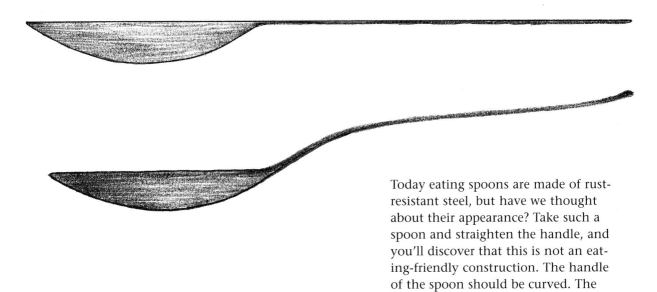

Today eating spoons are made of rust-resistant steel, but have we thought about their appearance? Take such a spoon and straighten the handle, and you'll discover that this is not an eating-friendly construction. The handle of the spoon should be curved. The same is true of wooden spoons.

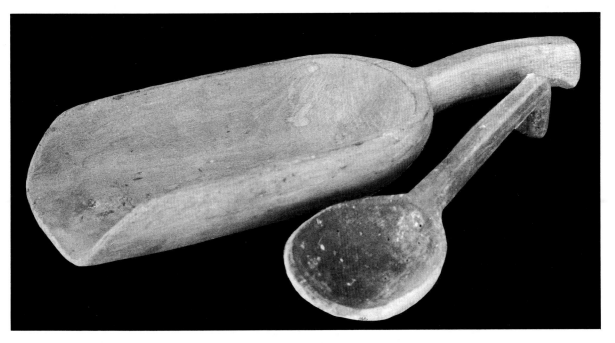

Utilitarian items were shaped according to their intended use. Here is an old scoop that was probably used for scooping seed, and a rough, chopped-out ladle, probably used in preparing food for animals on the farm. Both have fairly straight handles compared to the scoop on the previous page.

75

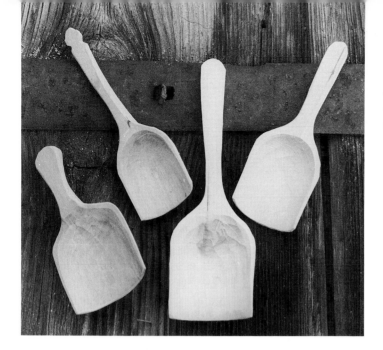

A few small, newly carved scoops open at the front and with slightly curved handles.

Sketches should form the basis for all wood-carving. Draw enough to come up with various ideas and designs, like these for small spoons and scoops.

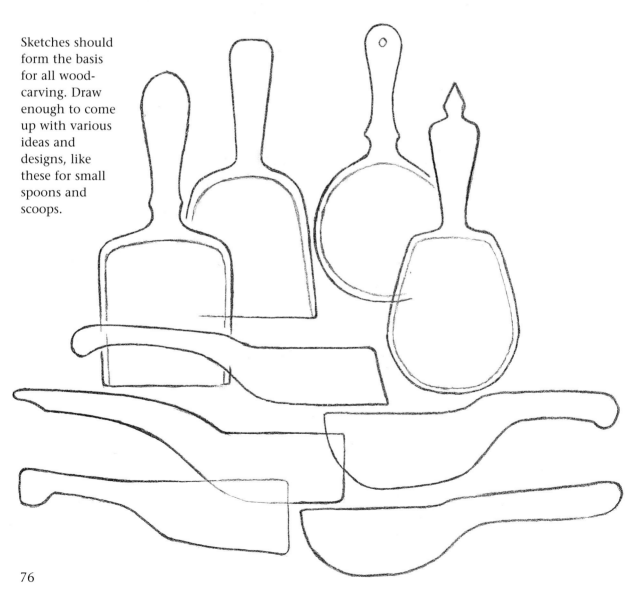

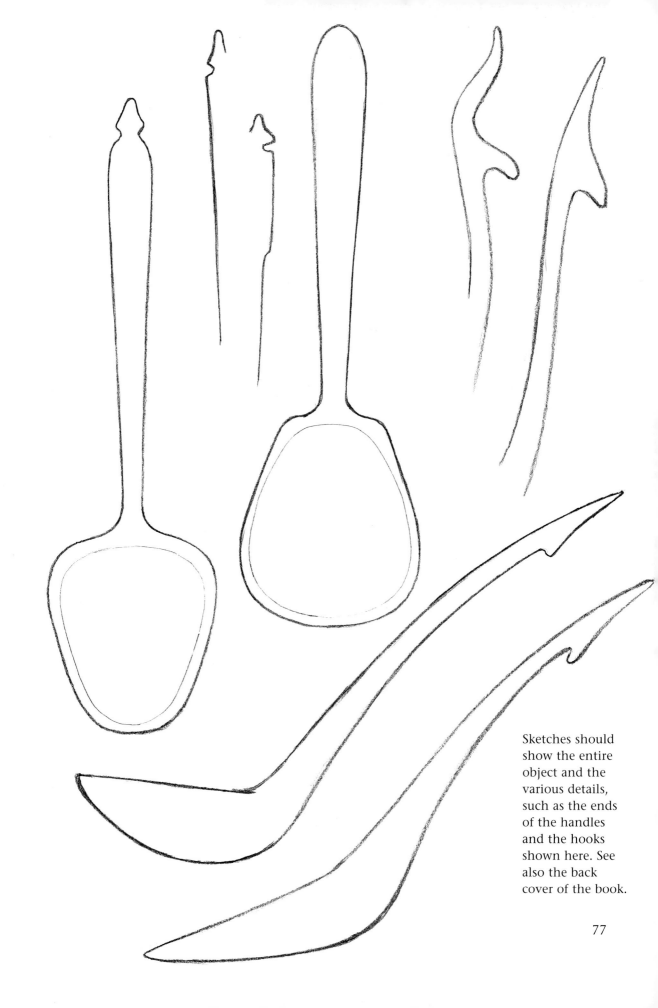

Sketches should show the entire object and the various details, such as the ends of the handles and the hooks shown here. See also the back cover of the book.

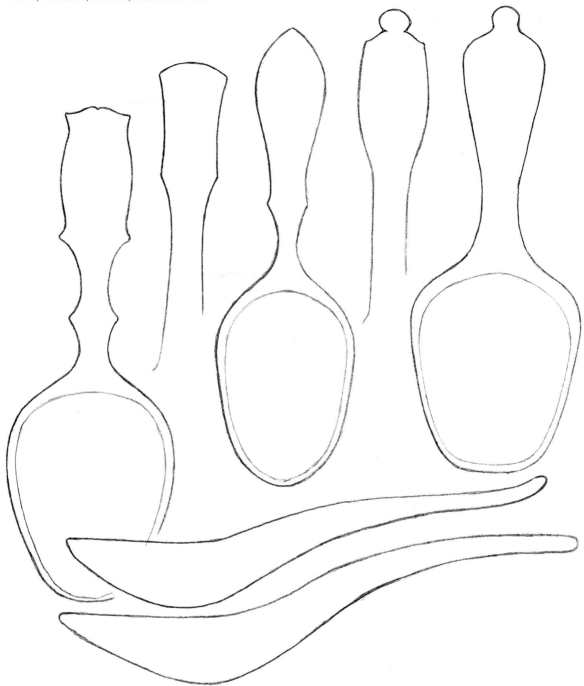

Above: When you look at a spoon from the side, the thickest part should be the bottom of the spoon. If you look at the spoon from above, the narrowest part of the handle should be down toward the bowl of the spoon.

Top right: Three spoons that were modeled after old-time eating spoons.

Bottom right: Spoons with beautiful egg-shaped bowls. The material in both of these is sallow and juniper.

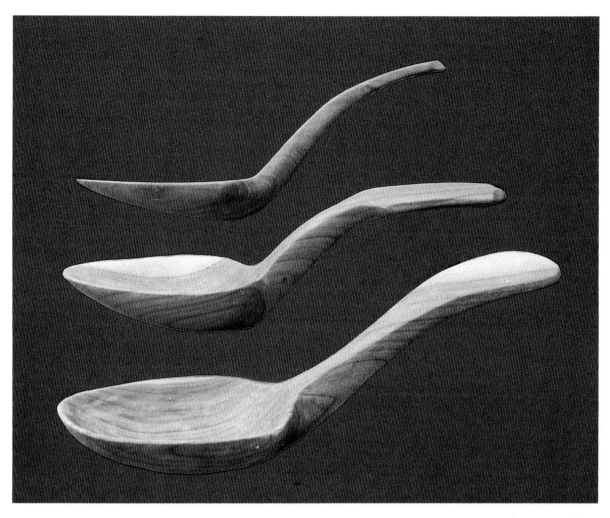

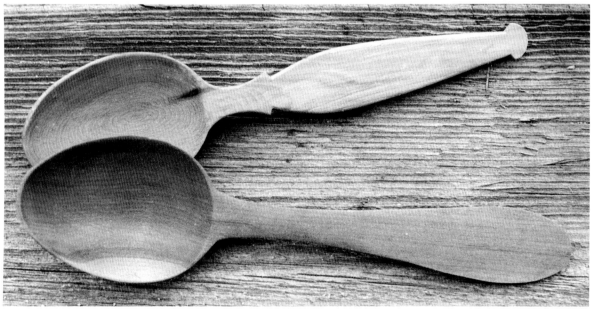

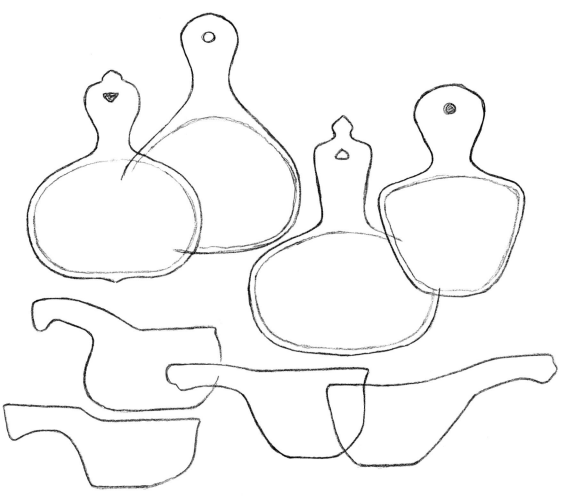

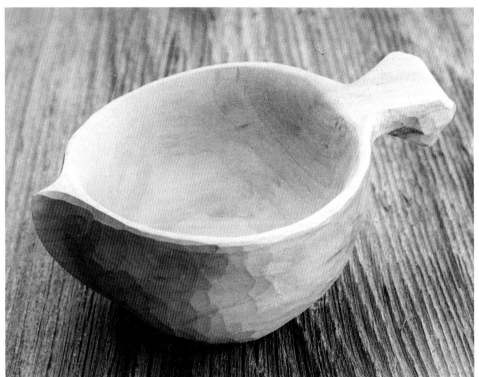

Above: A *kåsa* (a one-handled drinking cup) is often short and wide. The handle can be more or less angled upwards.

Left: *Kåsa* with the end shaped like a bird. It has been polished smooth on the inside, but the knife cuts have been left on the outside.

Right: A couple of somewhat shallower *kåsa*s. These have longer handles with holes so a hanging strap can be attached.

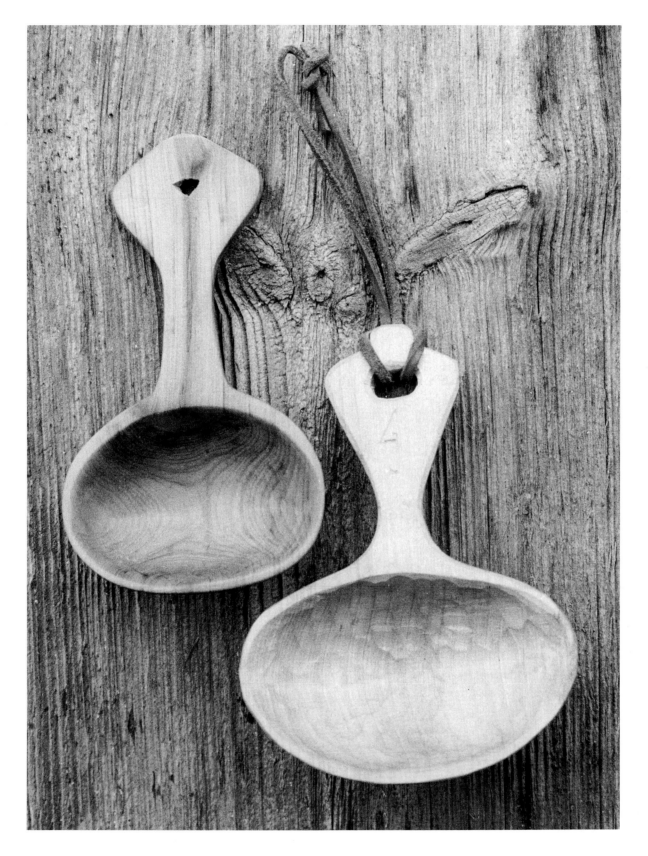

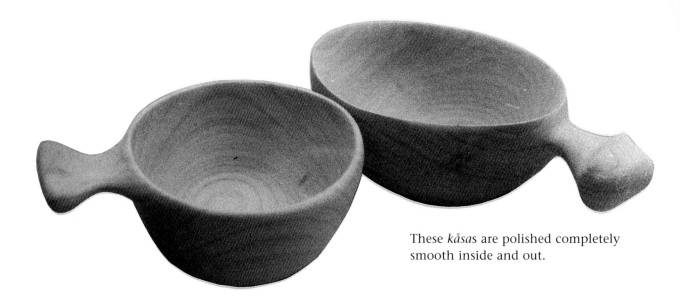

These *kåsa*s are polished completely smooth inside and out.

Scoops with different profiles and handles of various constructions.

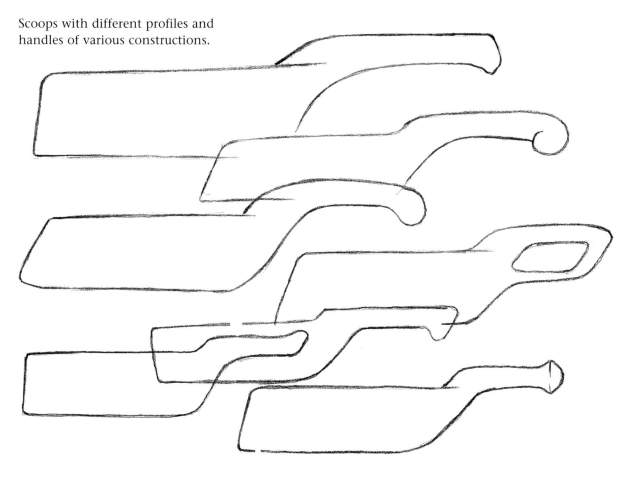

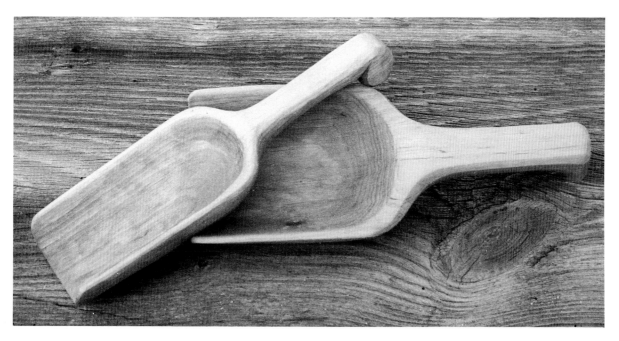

Scoops in alder where the surface
cutting has not been smoothed out.

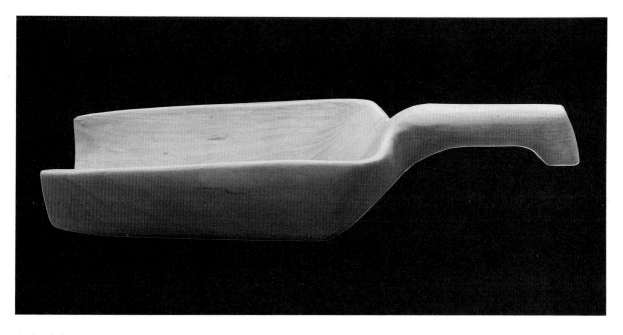

A thick birch scoop, with a polished
surface that suits the smooth structure
of the birch.

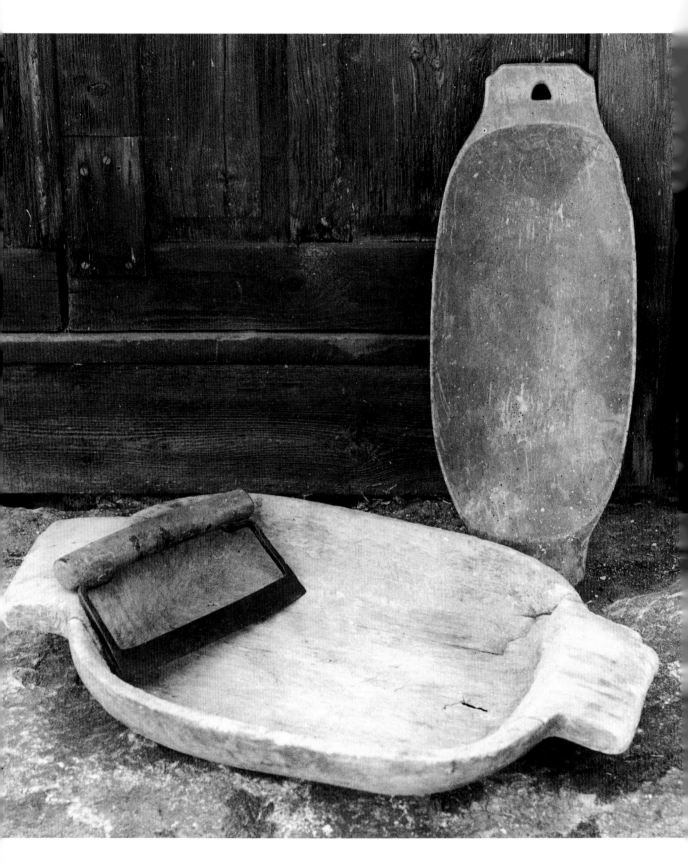

Troughs, Basins, and Bowls

Two old troughs. The front one was used for chopping meat with a hacking iron. The other, more-slender one was used as a kind of basin for storing things.

For a long time thick troughs hollowed from logs were used in Sweden to store both solid and liquid goods and provisions. Each trough's specific purpose determined its shape and size. There were thick, robust ones used in fall slaughter for catching pig blood and preparing blood sausage, and others the right shape and size for the rough hacking iron used to chop meat for stuffing before the meat grinder was invented.

There were also troughs for baking bread. In old Swedish farming society they didn't bake very often, usually only a few times a year, so it was necessary to have a trough that was deep enough to mix the very large amounts of dough in.

Wood such as beech and birch that gives off neither smells nor tastes was needed for cheese molds and troughs for storing milk and butter.

Slightly smaller troughs or bowls were placed on the table at mealtimes. The porridge was eaten by everyone from one common bowl in the middle of the table.

For parties and guests, slightly smaller and slenderer dishes and bowls were used. These were sometimes decorated with some type of chip carving on the edge, and those intended as gifts were usually decorated a little more. In olden times, decorations were not just for beauty; they were also supposed to magically help the object serve its intended purpose.

Today bowls and basins are carved for other uses. They can store bread and cakes, fruit, or Christmas nuts. They can be carved out of green or dried material. If you use dried wood, the

material is generally secondary to the intended shape. In working with green wood the opposite is often the case: the final shape is partially determined by the material you are able to obtain.

Two bowls of pine where the annual rings are completely different. The rear one was carved from significantly faster-growing wood from southern Sweden, while the front one was made from northern pine. The one in back has the heartwood side up while the front one has the heartwood side down. This results in two entirely different patterns.

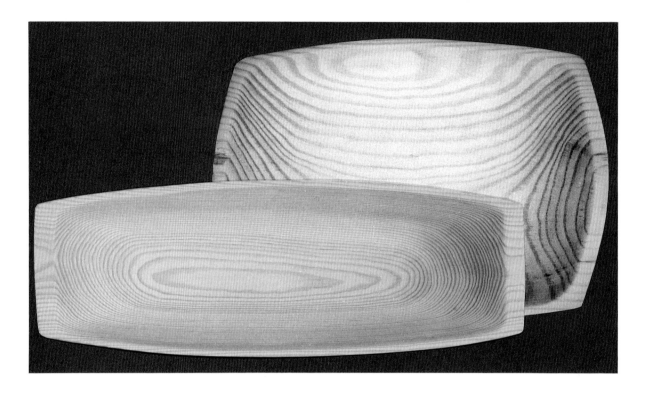

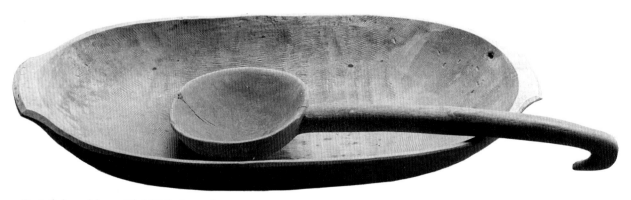

Tasteful and beautiful little trough with small handles and a scooping ladle with a hook on the end.

The ends of the bowls can be shaped
with simple slopes or more-defined
handles.

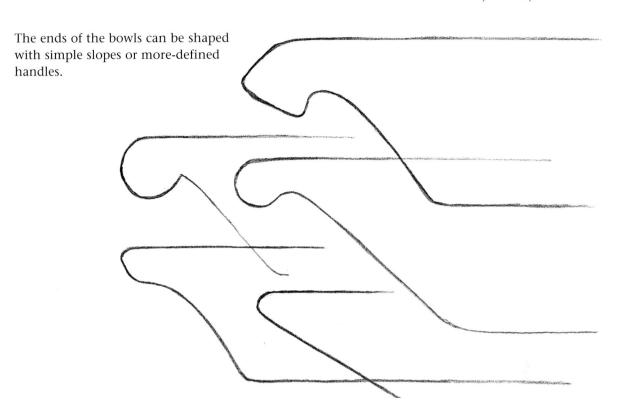

A bowl can be rounded, oval, or
practically square. The corners can
curve inward if you want some type
of handles on the ends.

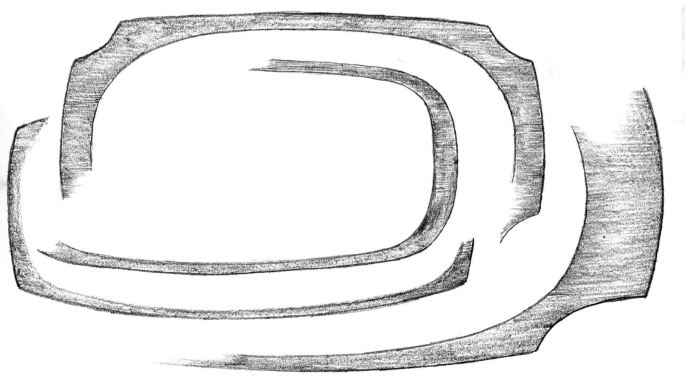

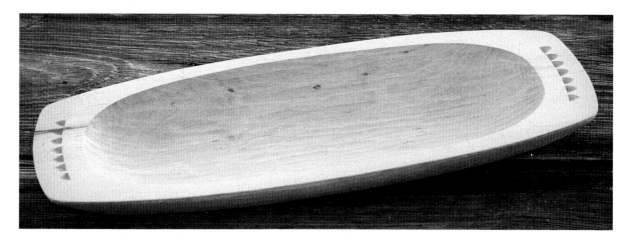

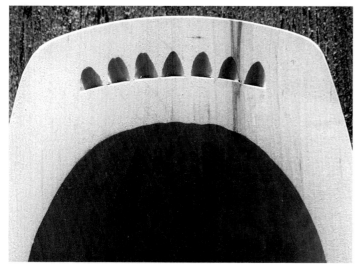

Above and left: Small trough with a simple shape. The smoothly polished upper edge makes the decorative nail cuts stand out in contrast.

Below: Troughs with handles on the ends. The insides were cut across the grain and left rough, but the upper edges were polished smooth.

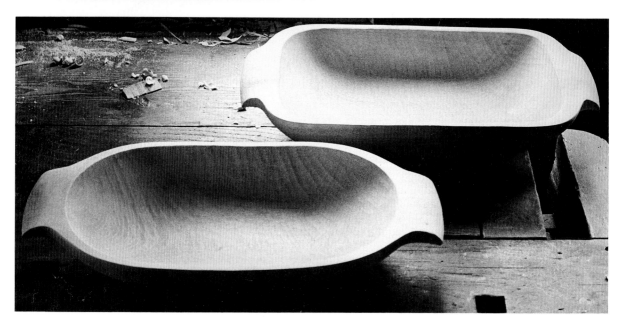

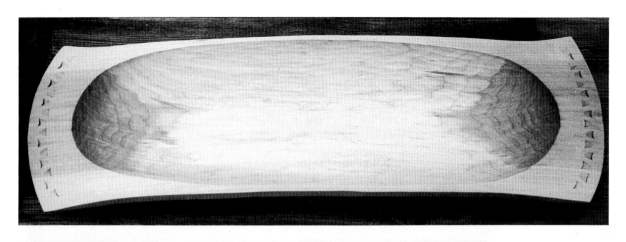

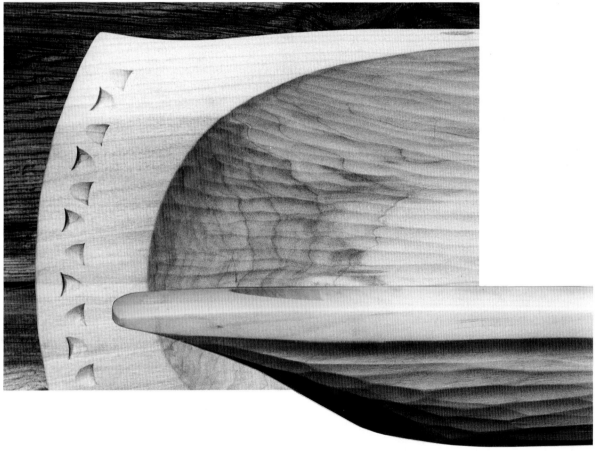

Different views of a large trough
carved from sallow. The trunk's
slightly curved shape has been
preserved. The trough's edges have
been polished smooth on the top
and the outside, and nail cuts
decorate the curved ends.

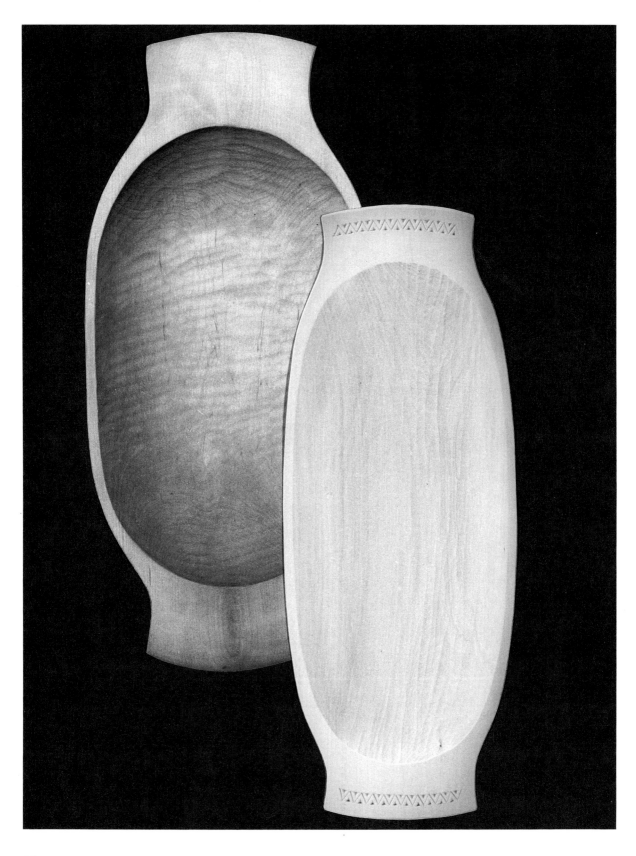

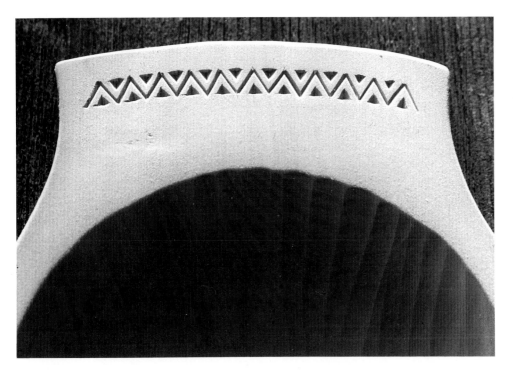

Far left: Newly made troughs with their insides left unpolished. One was cut clean across the grain; the other one was cut in the same direction as the grain.

Top: This trough carved in linden has been left unpolished inside and out, but the upper edge was polished smooth and given a frieze of combined tip cutting and chip carving.

Bottom: The profiles of a couple of troughs where the handles have been made to curve down to provide a good grip

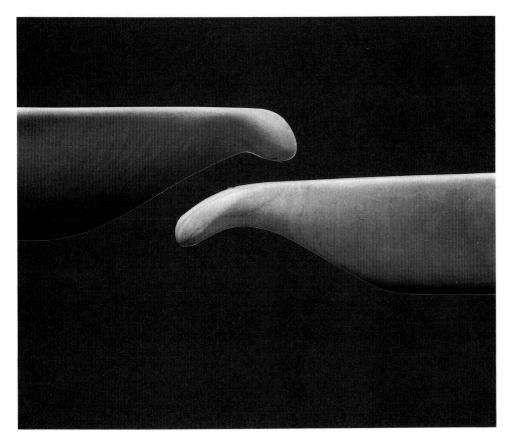

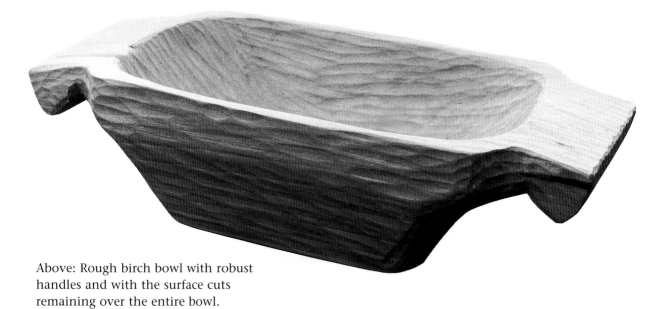

Above: Rough birch bowl with robust
handles and with the surface cuts
remaining over the entire bowl.

Bottom left
and to the right:
Burls provide
lively patterned
wood that is
excellent for var-
ious types of
woodworking.
Making bowls
by using the
original shape
of the burl can
give rise to
exciting solu-
tions. However,
polishing it
smooth is a
big job.

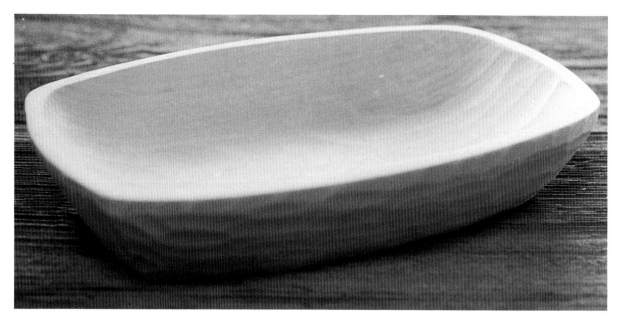

When you cut bowls, the marks made by the chisels and gouges can be left. Light sanding can even out the top edge.

Hollowing out bowls of dry wood attached to a carpenter's bench

When making a bowl in woodworking class in school, you usually use dry material. In the lower grades it's necessary to use wood that doesn't resist too much. Linden is an excellent choice. In advanced classes, alder, birch, or pine may be appropriate.

The job should be based on a paper model of the bowl viewed from directly above. If you want a symmetrical shape, draw one corner of the bowl onto a piece of paper that's been folded twice.

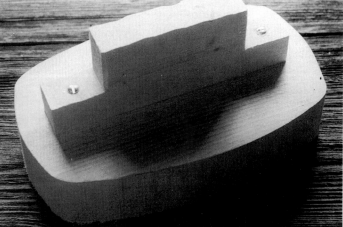

1. A paper model is traced to sketch the design onto the workpiece. The design is then sawed out along the lines.

2. A support block is attached to the side that will become the inside of the bowl.

3. Firmly attach the workpiece by fastening the support block to the rear of the carpenter's bench. Place a protective piece between the wood you are carving and the carpenter's bench to protect the bench during further work. The carving of the outside is then done with a chisel and mallet and finally with a flat gouge or a spokeshave.

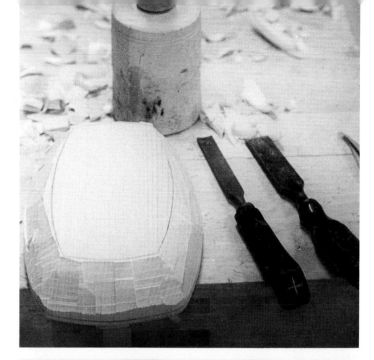

4. Once the outside is ready, the first support block is unscrewed from the inside of the bowl and a new one is glued onto the bottom of the bowl.

 It's important to be able to remove the support block when the bowl is done. So put a piece of paper between them as shown in the sketch.

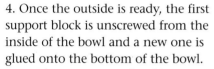

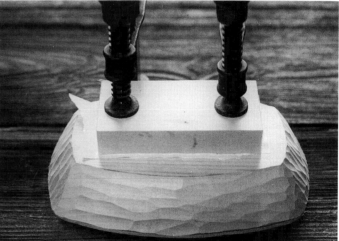

5. Wait a few hours before continuing. Because the pressure during hollowing out is great, the glued-on support block must sit properly. The first rough hollowing out is done with a mallet and gouge with the workpiece attached firmly to the rear of the bench. Chop from two directions the entire time and at a slight angle in toward the middle in order to avoid flaking.

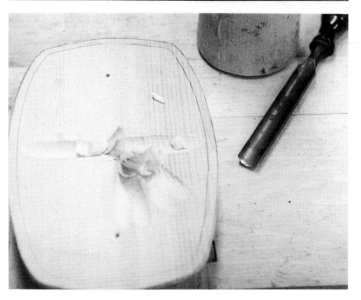

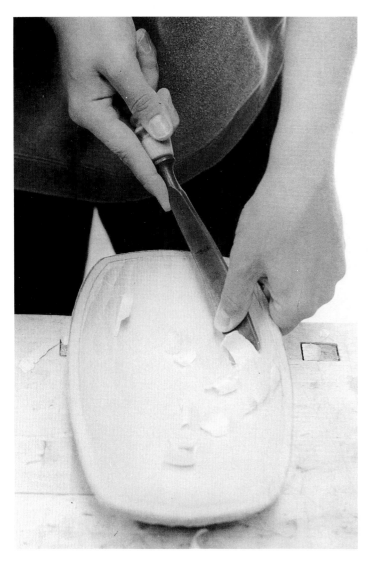

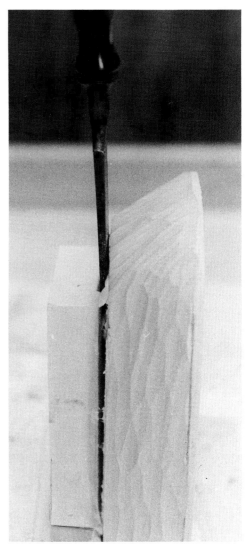

6. The final internal cutting is done with a curved gouge.

7. Remove the glued support block by placing the block against the carpenter's bench and inserting a broad wood chisel between the two pieces of wood where the glue is. Plane or sand off the paper and glue residue that remains on the bottom of the bowl.

Shaping bowls with spokeshaves

1. Sometimes it's necessary to simplify tools and techniques to suit various conditions. Sture Tholander in Linköping, Sweden, has a great deal of experience with this: he has constructed several tools that simplify the job. His spokeshaves are excellent. The straight one is for shaping a bowl on the outside. The two with the crosswise handles and convex edge lines make smoothing out the inside of a bowl easy.

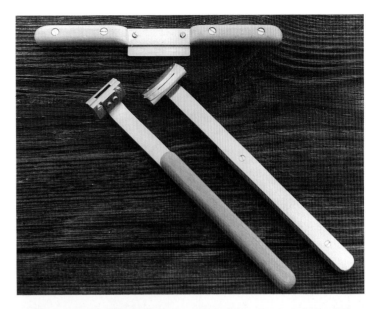

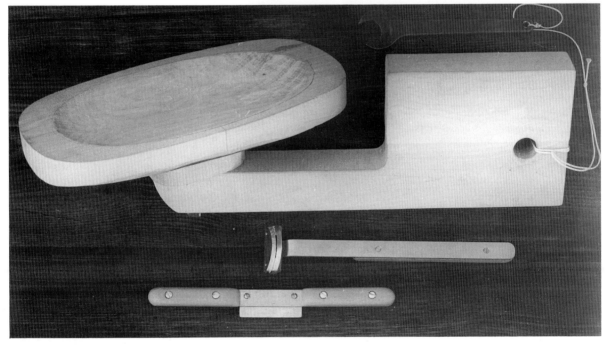

2. An excellent tool for this job is a special support block that makes it possible to turn the bowl in various ways and work alternately on the inside and outside.

3. A small block is glued to the bottom of the bowl, to be removed later. A lag screw is screwed tightly into the bottom of the block.

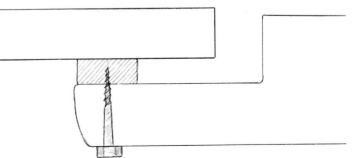

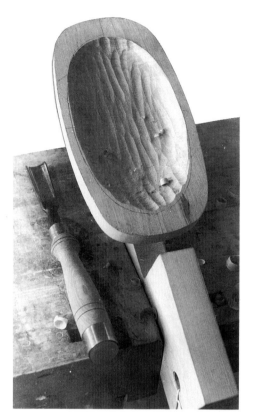

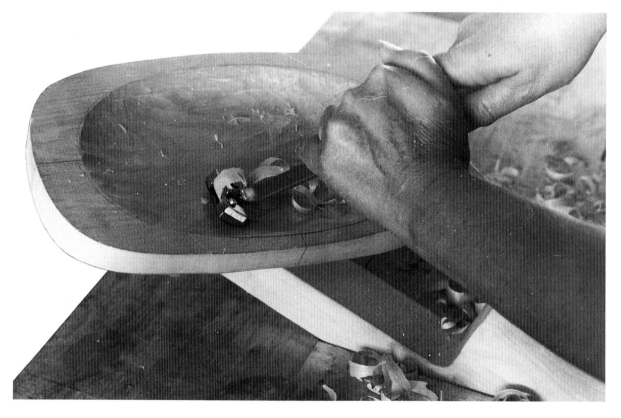

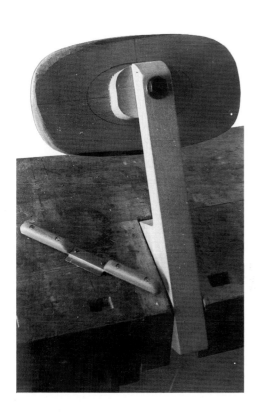 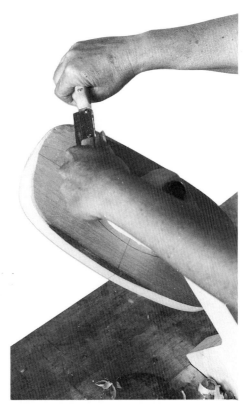

4. The support block is attached to the carpenter's bench and the object is roughly hollowed out with a gouge.

5 and 6. The hollowed-out area is smoothed with a spokeshave with a convex edge, while the bowl is placed in various positions as needed.

7 and 8. The outside of the bowl is worked with the straight spokeshave in the same way.

Hollowing out with the help of the Supercut disk

[Editor's note: Blades that perform similarly to the Supercut disk go by different names in different countries, depending on the manufacturer; they are available from specialty tool companies.]

If you want to take a step away from handwork and mechanize the production of a bowl or trough, you can use the Supercut disk. This disk, which can be installed on an angle grinder, has teeth that are similar to those on a chain saw. The fine thing about this disk is that it has a slip feature and can not get stuck in the material. Certainly it requires less strength to use than an adze, but the problem, as is the case with almost all machine work, is that it rumbles and the shavings fly.

In this case we are starting with a 3-inch-thick (75mm) sallow plank.

1. The bowl is roughly hollowed out with the Supercut disk.

2. Next the inside is worked with an adze.

3. Further hollowing out is done with a mallet and a gouge.

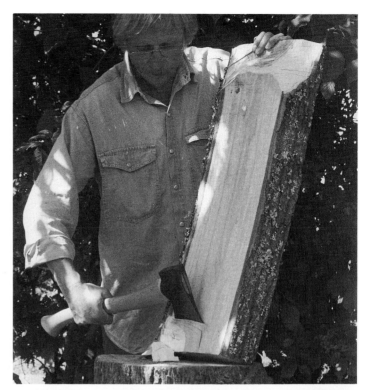

4. Once the inside is roughly worked, then the outside is roughly hacked with an ax.

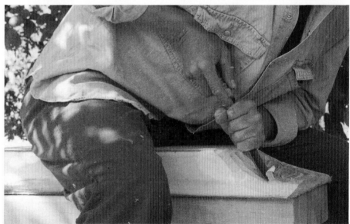

5 and 6. After the roughly worked wood has dried, the final cutting of the outside and inside is done with the help of a curved gouge and the top is planed level.

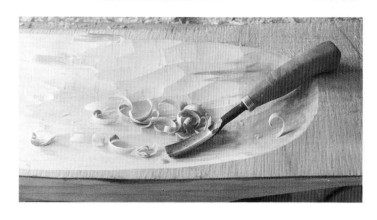

The finished bowl is on page 89.

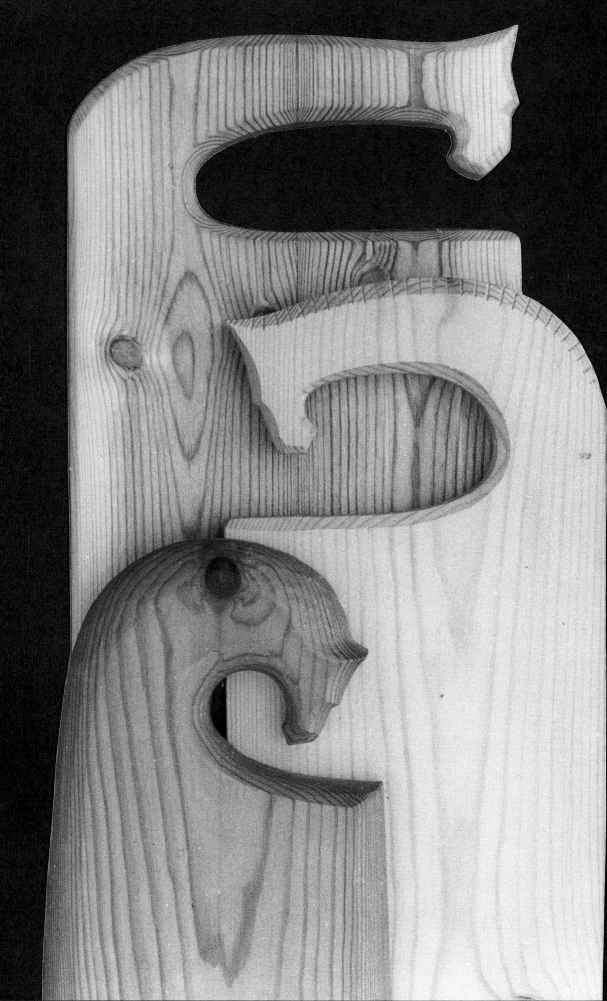

Horses, Dragons, and Birds

Cutting boards with horse shapes on the handles. When delicate necks run across the grain it's smart to drill in from the side and insert a pin across the grain to strengthen it.

The old-time Scandinavian woodworkers often used animals as their models or sources of inspiration. Suitors were especially eager to emphasize both beauty and strength in their work. Since the animal that stood for strength above all others in farming society was the horse, it was depicted in many different versions. For example, mangle board handles were often horses.

To give magical powers to the motif, dragon-like shapes were used instead. These appeared during Viking times on both ships and various carved objects, such as the *kåsa*.

Horse shapes often appeared in old handcraft products, such as this handle for a scutching knife. Sometimes the figures were true to nature, but sometimes they were, like this horse, greatly stylized. Is that a manger the horse is leaning over?

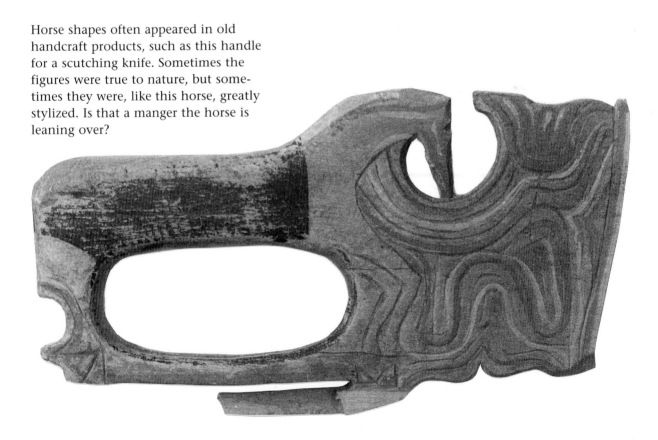

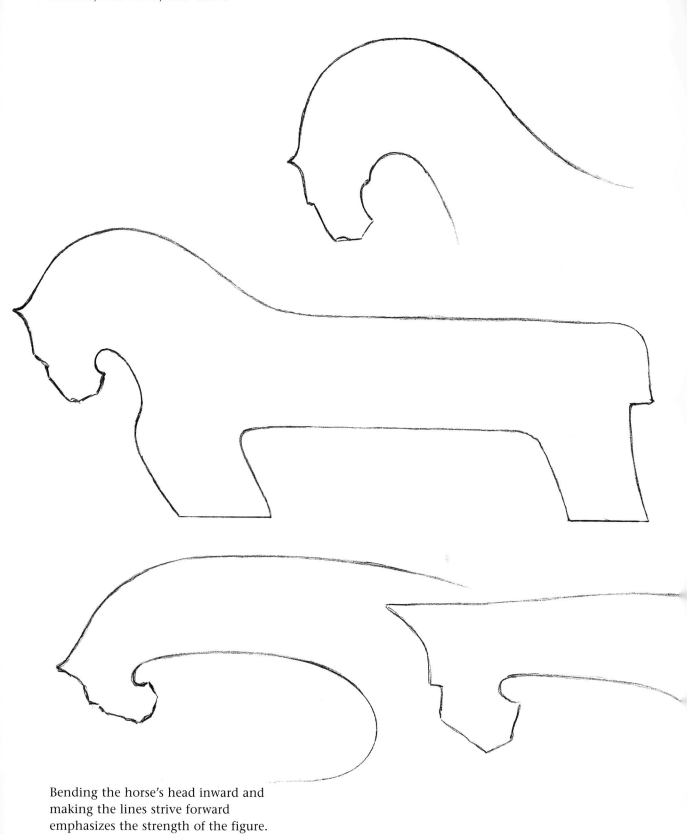

Bending the horse's head inward and
making the lines strive forward
emphasizes the strength of the figure.

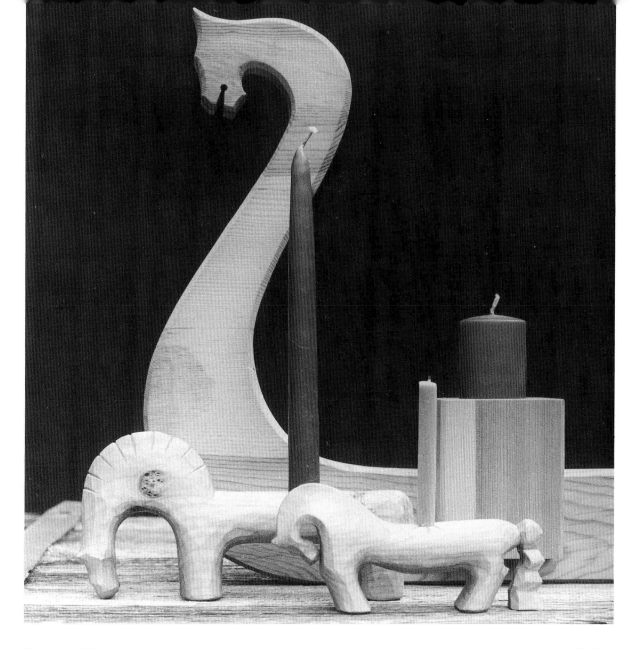

Candle holders in various shapes where the horse and dragon served as inspiration. The horse candle holder carved from linden contains the roses of the wood. These roses are formed beneath leaf-covered knots that are often found on thick linden trees.

Birds were a special motif. At large parties the beer was served in big bowls shaped like birds, the so-called beer geese. These were often carved out of burls from tree trunks or other naturally shaped pieces of wood. A smaller, bird-shaped bowl for drinking out of would swim inside a large beer goose.

Allowing yourself to be inspired by these old Scandinavian traditions is an excellent way of integrating history with active woodworking.

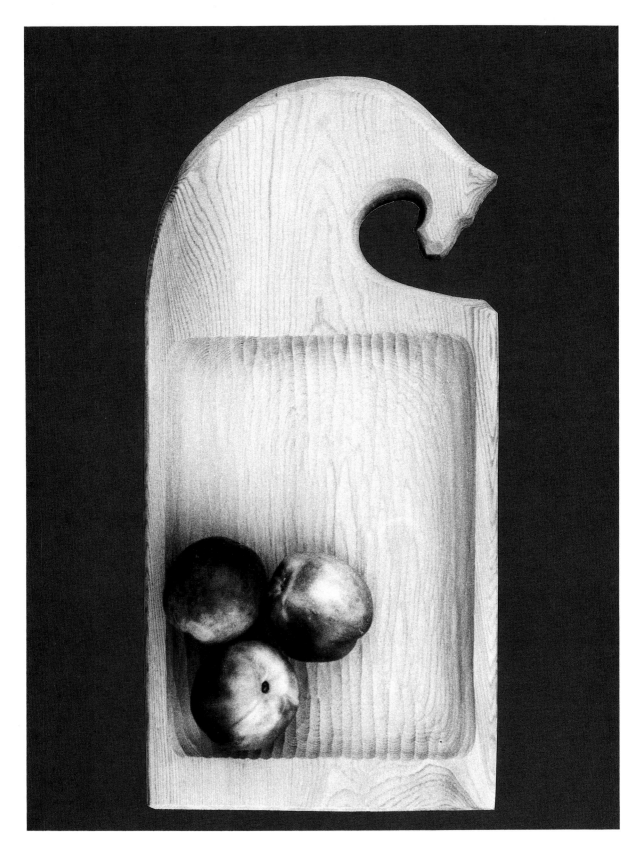

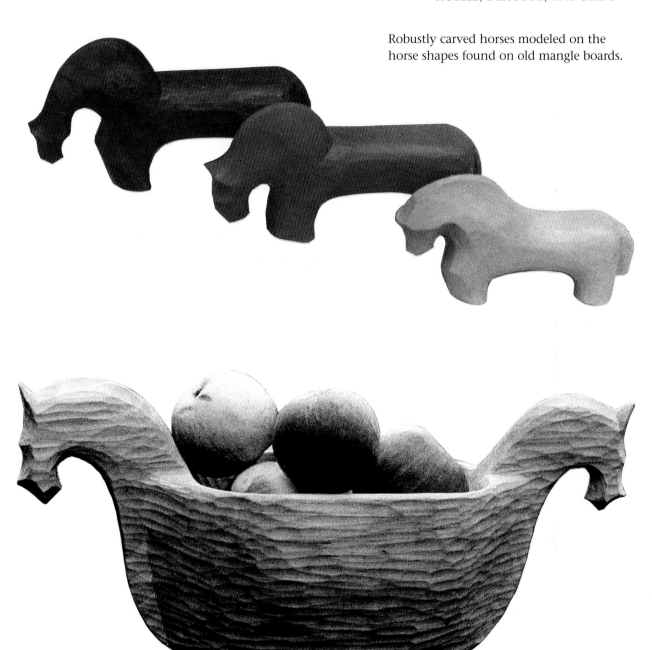

Robustly carved horses modeled on the horse shapes found on old mangle boards.

Roughly carved bowl with horse shapes on the ends.

Left: If you want to make a cutting board a little more bowl shaped it's easy to hollow it out. The roughly carved outer surface of this one fits well with its robust shape.

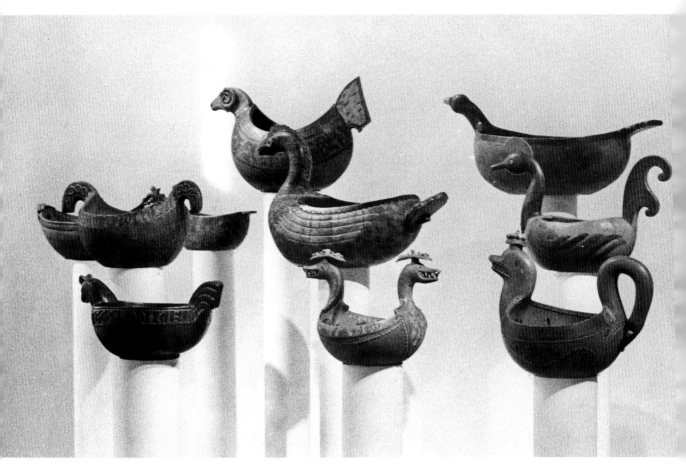

In old times beer was served at fine occasions in large, carved bird-shaped bowls, the "beer geese." Smaller bowls that the guests drank from swam in these beer geese.

Carved wooden bird decoys were placed out on the water when hunting to attract real birds. These decoys are well shaped and painted in natural colors.

Different head and beak shapes bring various types of birds to mind.

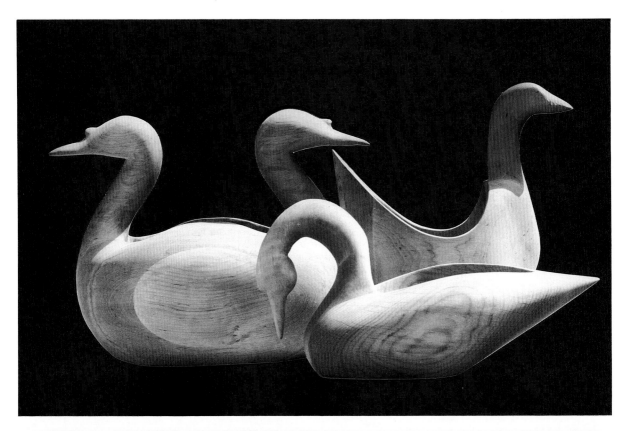

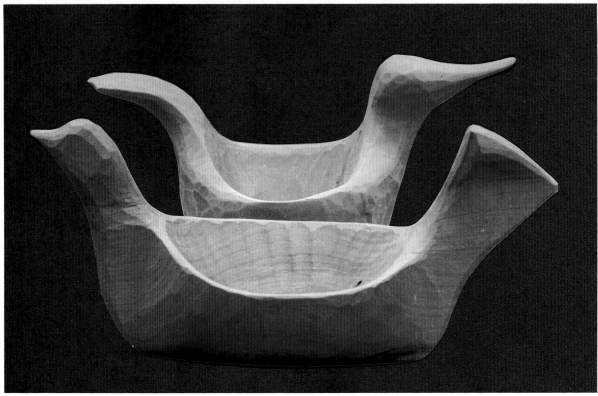

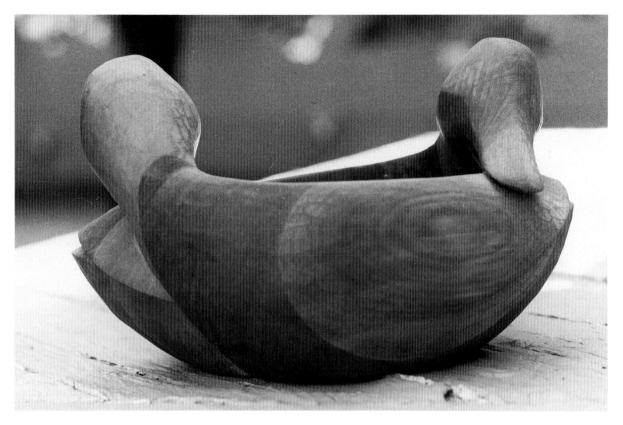

Top left: elegant swan-shaped bowls carved in alder and polished completely smooth both inside and out. In the two at the top right the direction of the wood grain in the throat section has been turned vertically so that it can handle the pressure on the material.

Bottom left: Two smaller beer geese, or possibly scoops, carved in whole pieces, with the knife and gouge cuts remaining.

Above: Bowl consisting of two ducks turning in toward each other. The various sections of this bowl were carved from one piece of wood and then glued together.

In the robust bowl below, the roughly carved surfaces contrast nicely with the polished sections. The middle sections were sawed out before being glued together.

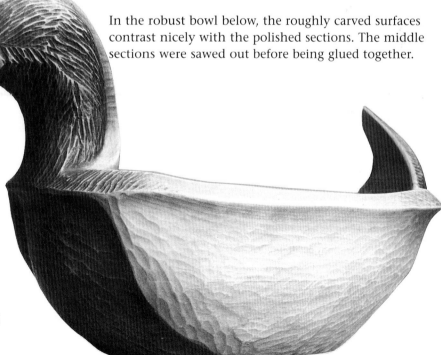

Linden is an excellent wood for carving. The woodpecker
and magpie above are in natural sizes and painted in
colors that are true to nature.

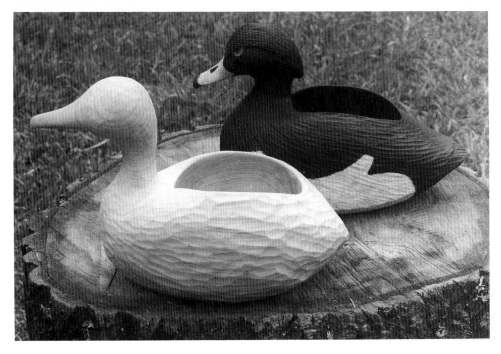

Small ducks
carved in linden.
The woodworker
was clearly
inspired by both
the naturalistic
shape of decoys
and the bowl
function of
beer geese.

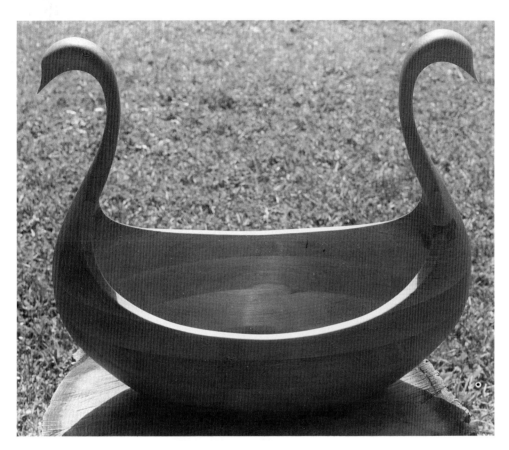

This elegantly shaped bowl has the character of both gracious swans and swiftly sailing Viking ships. The head and neck sections contain vertical wood while the bowl consists of horizontal layers that have been glued together.

Which came first, the chicken or the egg? Here two egg shapes fit together to make a bird.

113

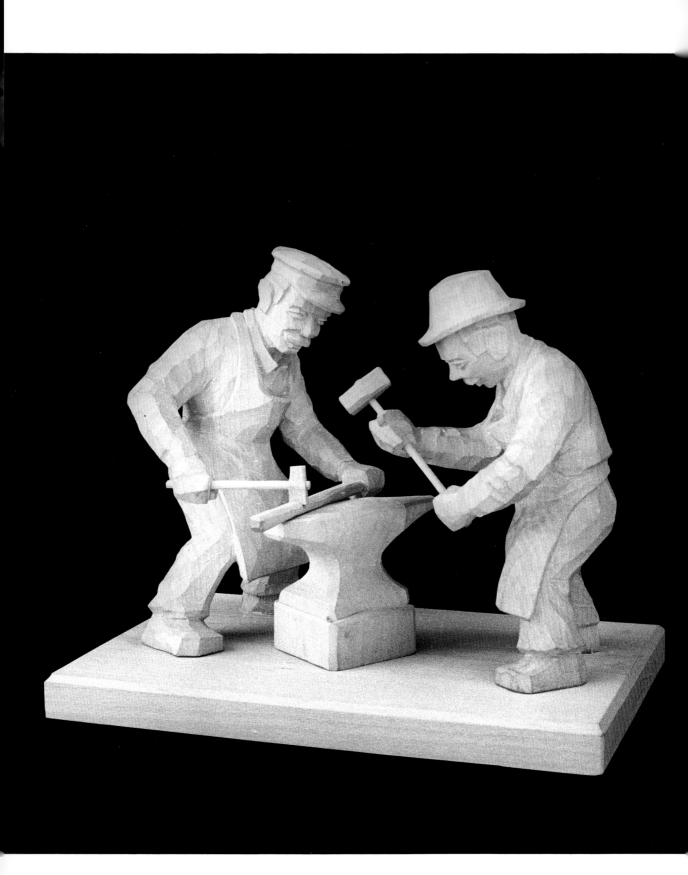

Whittling Figures

Bjärnum in southern Sweden has been a sort of center for cabinet making and wood handcrafts. Several of the old woodworkers had a hard time abandoning wood in their free time, so some of them devoted themselves to carving. One of the most successful ones was Alve Nilsson, who supplied the local district museum with a good number of figures depicting various situations and activities, such as these smiths at work at the anvil.

Whittling old men and other wooden figures is a popular hobby among people interested in wood handcrafts. As we mentioned before, this has long been a pastime among people living in the Swedish countryside and woods. The lumbermen in their log shacks had to pass the time on dark winter evenings. Old men at the charcoal pile endured long watch shifts sitting at the pile as the smoke rose.

These people who lived in the woods carried carving knives to their work and had the material nearby, so it was natural for them to scratch on a piece of wood. Perhaps it turned into a person or a horse, or perhaps it became some kind of household utensil. Most of the time it probably didn't turn into anything at all. The knife was just used for unplanned scratching while they relaxed from the day's toil.

Country children got their own carving knives at an early age. They made bark boats and figures from the wood chips in the woodpile. These traditions were inherited down to the middle of the 1900s when prefabricated toys made their breakthrough.

Of course the materials used for whittling varied. Often people used what they could find. It's possible to use nearly every type of wood, but alder is one of the most suitable and was the

favorite material of the famous sculptor Axel Petersson, the "Dödarhultar." Linden is another type of wood that is sought after for this type of work (as it is for other woodworking) because of the fact that it is soft, hearty, and tight.

The carving knife is the common tool for whittling figures. A well-sharpened carving knife with a short, pointy blade reaches most tight angles and

The two upper photos, below, show a couple more of Alve Nilsson's figures: a musician who scrapes his fiddle and old women gathered at the water pump.

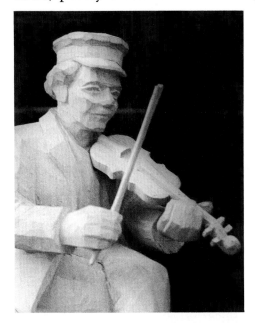

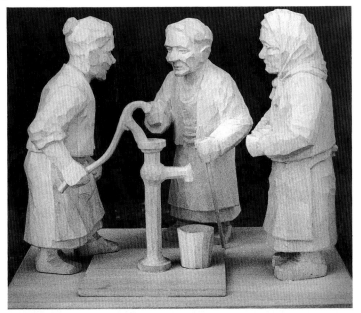

Above: Three steps showing one way of making a figure. First, the profile of the figure is sawed out according to the sketch. Next it is sawed and roughly cut into a shape from the other direction, and then the final carving is done with a knife. It's important to use a sharp knife to create all the fine details.

Right: Most smaller figures can be held by hand when working on them. For slightly larger objects a special carving clamp can be useful. It's inserted through a hole in the carpenter's bench and screwed into the workpiece to hold it in place while making it easy to turn.

Bottom left: A work by Per Ingvar Olsson. He carved most of his naturalistic figures from willow.

corners. Various gouges can be good, too, particularly if you want to work with the piece attached rather than holding it in your hand. Before whittling, however, it is appropriate to cut out the rough shape of your object with an ax or, even better, a saw from two directions where the contours are marked (see the photo and directions above).

117

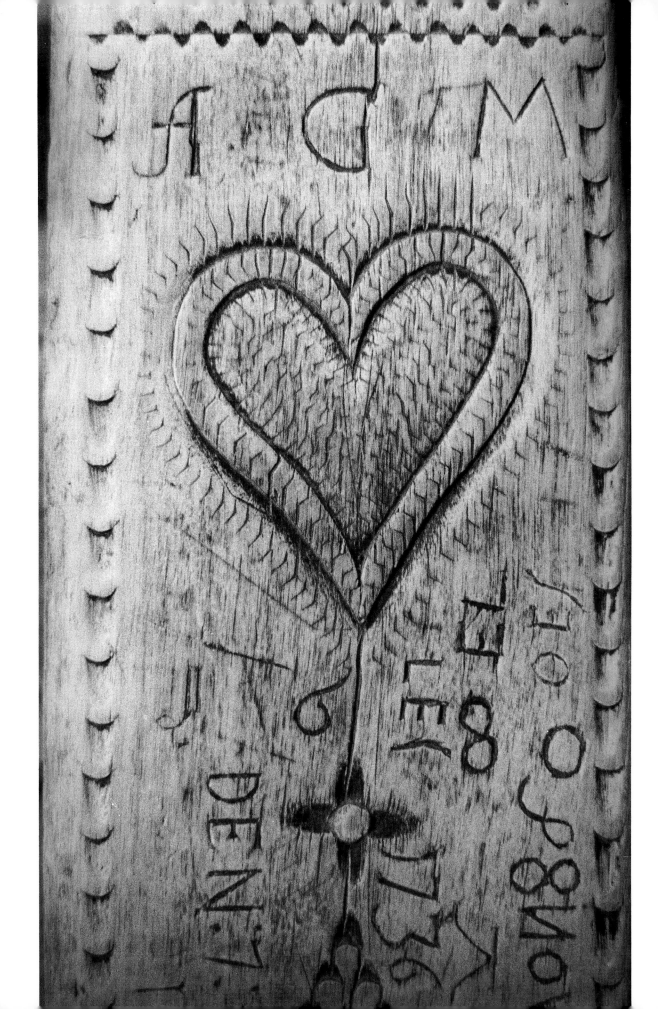

Carving Patterns

The old mangle boards were often covered with carved decorations made by tip cuts, nail cuts, and chip cuts. The heart on this central Swedish mangle board indicates that it was some type of suitor's gift.

Patterns have been carved in wood since prehistoric times. At first, the ritual significance of these patterns was at least as important as their beauty. Decorated hunting tools were supposed to bring good luck in hunting. Decorated food vessels were to ensure good food and to prevent it from becoming rotten and moldy. The decorated tools of the craftsman contributed to his work being well done and long lasting. Perhaps the feeling of satisfaction and harmony that comes from creating beautiful and well-shaped objects *did* contribute to the work being done well.

The first decorations were scratched into wooden surfaces by pulling sharp objects over them. Soon polished decors were created. The tip cut, which is made with the tip of a knife, is fairly simple. [Editor's note: see page 128.] It consists of two vertical cuts that form a V on the surface of the wood. The cuts are shallowest at the outer ends and deepest at the point where they meet. The triangle in between the two cuts is poked out with the tip of the knife so that an inclined plane is created.

A nail cut is a rounded cut made by a gouge. [Editor's note: See page 128.] This cut is best made in the direction of the grain. Straight cutting of the grain can either be done with a knife or with a flat or slightly rounded chisel or gouge that is sharpened to a curved end on the blade.

V-grooves, made by placing two slanting cuts that meet at the bottom, are used to build lines, entire loops, and patterns. These lines can

119

be either cut with a knife or with a slanting straight gouge or chisel.

If you want to simplify the V-groove somewhat, and don't mind if the cut is slightly rounded instead of completely pointy at the bottom, a special gouge called a "goat's foot" can be used. [Editor's note: This is similar to the tool called the "V tool" or "parting tool" in the United States; see page 160 for photos.] Well sharpened, it's a good tool, but it requires a great deal of practice to be able to sharpen it correctly. The bevels on both sides have to be cut the same with something of an angle leaning in toward the lower edge, and the bevel has to go in a ways on the underside.

The chip cut, which is often made up of various circular shapes or geometric patterns, is best made with a special chip-carving knife. This knife is also suitable for the previously mentioned tip cut and V-groove.

It is fairly easy to make patterns for these chip cuts with the help of a compass. Make a circle and

The lapping technique was also very important in olden times. It's possible to tell that these small boxes are of southern Swedish origins because the lids are completely wrapped inside. In northern lapped boxes the centers have a rim around which the wrapping was done. Decorations on lapped boxes were often made by tip cuts, but sometimes they were produced with a branding iron, as was the case here.

then place the compass on the periphery of the circle and swing the arcs out so you divide it into sixths and create a six-petaled flower. A number of such circles can be interconnected to create an endless pattern. Even more variations are possible if you divide each sixth into two equal parts. Using this method you can divide the circle into 12 sections.

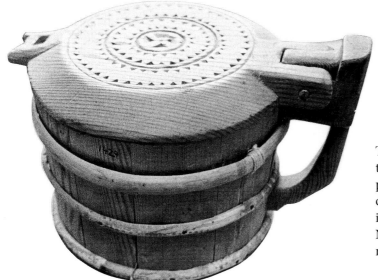

This pine stave tankard was found on the Danish Faeroe Islands, but it was probably made somewhere else, as pine doesn't grow on those islands. Perhaps it comes from Sweden or, more likely, Norway. The design in the beveled lid is made up of tip cuts and carved circles.

This trunk's strictly symmetrical decor has been constructed from squares and their diagonals plus shallow tip cuts that fill in the triangles.

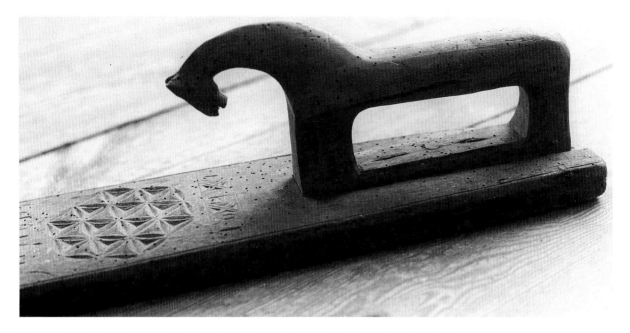

A mangle board from southern Sweden with a horse-shaped handle. The horse shape is associated with strength and stamina and therefore was a common suitor's gift. The beautiful chip-carving decorating the board is made up of overlapping circles divided into sixths.

This decoration on a trunk from central Sweden has been made out of circles also. However, here the chip carving has a very soft character because the cut-out areas have been rounded at the bottom.

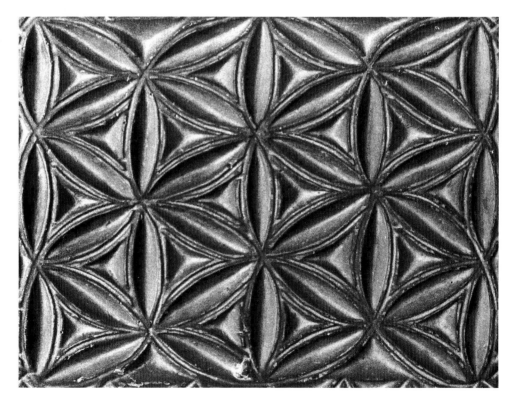

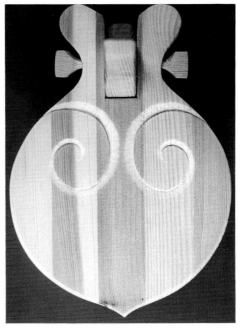

Near left: When carving loops it is necessary to use chisels and gouges that are of the desired radius or to have a steady hand so that cuts that go straight down into the material can be made with a thin-bladed, pointy knife. In this case the hollowed-out area that slopes inward toward the line was made later by a gouge.

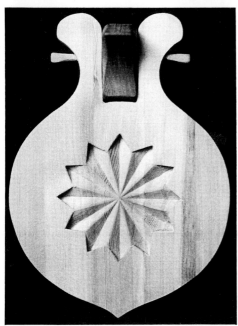

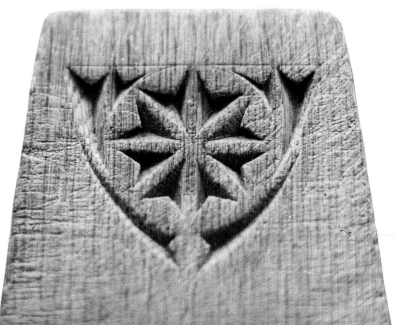

Far left, top and bottom: The waffle is still an interesting technique and makes a nice decoration for a tankard lid. The flower design in the top photo was made by the traditional division of a circle into sixths.

The rosette below is also based on a circle divided into six parts with the help of the compass. Each part was then divided in half to create 12 petals.

A well-used cutting board from the southernmost part of Sweden. Here, the circle has been cut into eight sections instead of six. The pattern was then completed with additional cuts.

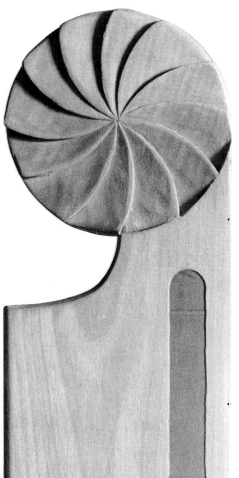

This design was created by dividing a circle into 12 sections as shown on the bottom of page 129.

Next page: The cutting board is among the woodworking projects that can easily become routine and boring. For variety, add a beautiful end that curves upwards and carve out decorations in the shape of a flower or other pattern.

Below: A round lapped box with a flower in the middle of the lid. The decoration was made with a knife and a gouge.

The lapping technique is an interesting old craft that there is every reason to continue. These boxes can be decorated in various ways on both the lid and the sides. The open pattern on the side of the round box was cut out before the pieces were joined together. The decorations on the lids consist of loops and heart-shaped petals made with knives and gouges.

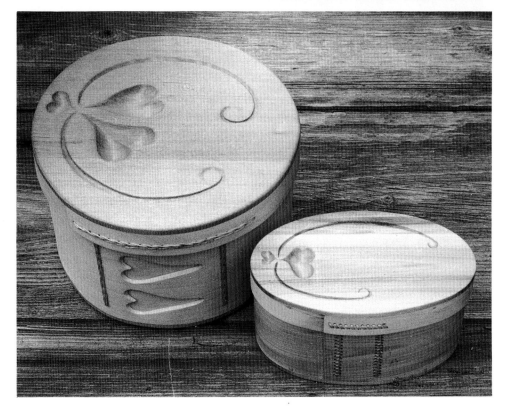

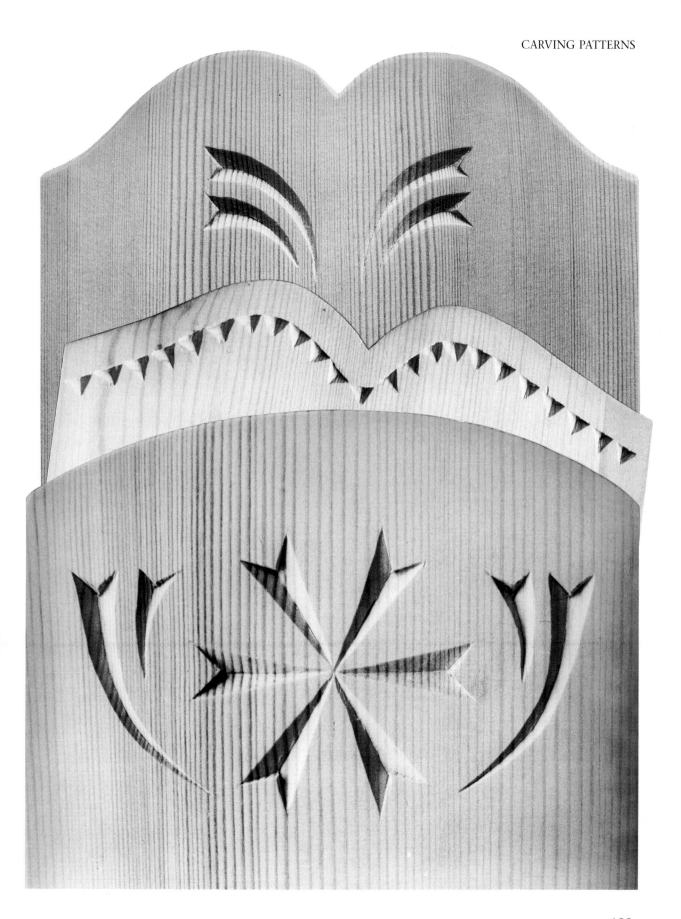

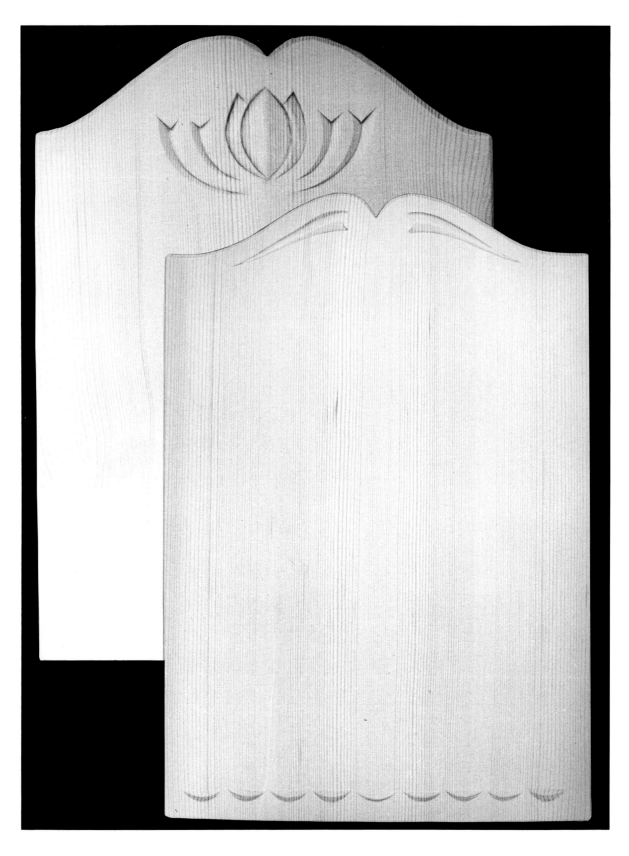

A few freely shaped flower patterns made with a combination of knife and gouge. Note that the main part of the V-groove is more or less across the direction of the grain. It is significantly easier to get a beautiful V-groove by using this method than it is if you cut along the grain.

V-grooves can be either straight on one side and angled on the other, as shown in the top drawing, or angled on both sides, as shown in the bottom drawing. They are cut in strokes by positioning the blade as shown in the sketches above right.

The photo to the left shows a few more ways that cutting boards can be decorated. For example, they can have a frieze made with nail cuts at the bottom.

Trails can also be made with the goat's foot, below. To work properly, this tool must be well sharpened.

127

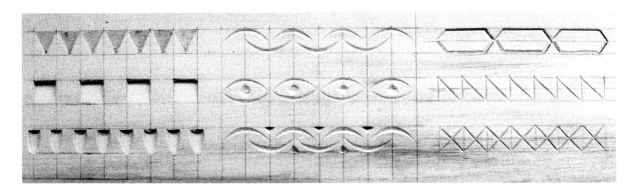

A few different versions of simple patterns. The three to the left were made from tip cuts and nail cuts. The cuts in the middle were made with gouges; the shape of each cut was determined by the width of the gouge used. Those to the right were cut with wood chisels in patterns determined by the width of the chisel. Note that the lines were drawn before cutting. The distance between the lines is primarily determined by the width of the chisel or gouge.

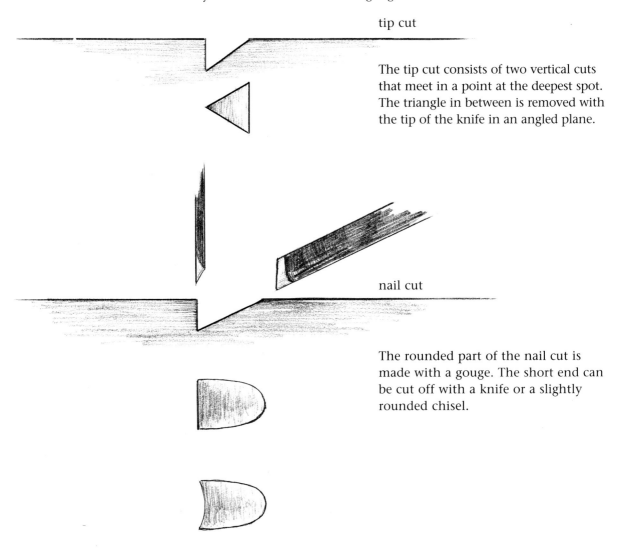

tip cut

The tip cut consists of two vertical cuts that meet in a point at the deepest spot. The triangle in between is removed with the tip of the knife in an angled plane.

nail cut

The rounded part of the nail cut is made with a gouge. The short end can be cut off with a knife or a slightly rounded chisel.

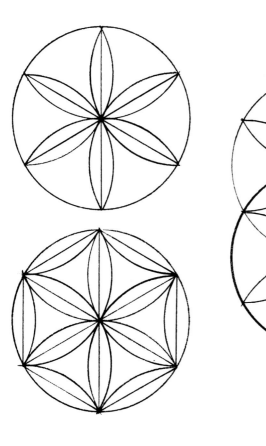

Chip-carving patterns can be constructed very easily with the help of a compass. Place the compass on the periphery of the circle and swing the arcs out so that you divide it into sixths, giving you endless patterns.

By finding the point directly between the petals of a circle that's been divided into sixths, you can divide the pattern into 12 sections. You can now build on these 12 sections to create various compositions.

129

Chip carving a rosette

1. The rosette is sketched with the help of a compass. First make a circle; then using the same radius, place the tip of the compass on the periphery and make arcs through the center as shown in the diagram. Try not to place any flower petals along the direction of the grain: it's always easier to cut more or less across the grain.

2. Place a ruler across the circle's center and two opposite petal points on the periphery. Make a vertical cut with the help of a knife or preferably a chip-carving knife.

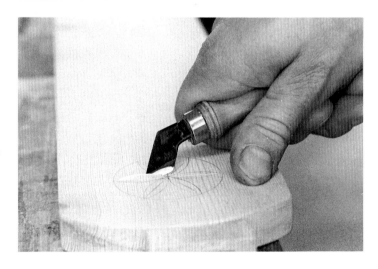

3. Hold the knife so that it is leaning and cut along the outer contours of the flower petal in toward the already made vertical cut. This cutting can also be done with a gouge, but then it will be even more important to take the direction of the grain into consideration.

Carving flowers with knives and gouges

1. Hold the knife at an angle and cut one contour of the leaf first. Make sure that the depth is greatest in the widest location.

2. Then cut the other contour the same way, so that the chip in between comes loose.

3. Make the straight edge of each flower petal using a vertical cut. If the petal is to be symmetrical, the vertical cut is made as a central line. The cut always has to be deepest in the widest places.

4. Then use a gouge to make a cut toward the vertical slice that matches the desired length of the flower petal. Make a rotating movement with the chisel or gouge so that the edge cuts down to the bottom towards the vertical cut.

5. The flower stem can be cut either as a V-groove or as shown here with a goat's foot. [Editor's note: An equivalent tool to the Swedish goat's foot would be the gouge called the "v tool" or "parting tool."]

See the details of the cutting board on page 127.

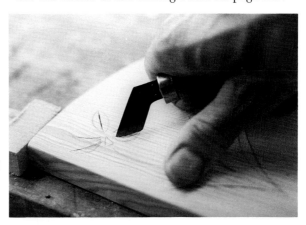

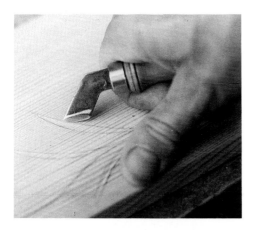

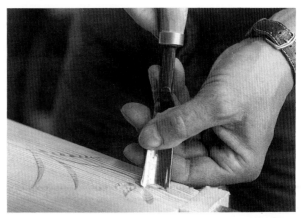

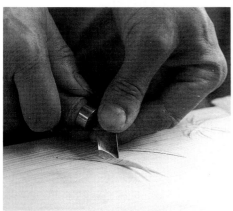

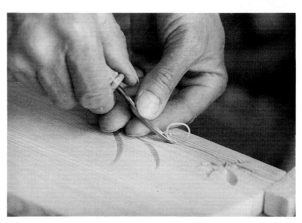

Carving leaf loops

1. Sketch the pattern on the workpiece. Gouges of various sizes can be used to make the bowl shapes of the petals and to cut out the sharply curved lines. Straight chisels with the bevel on both sides, the skewed chisel, and the knife are all alternative tools that can be used to cut the slightly curved lines and possibly the petal tips.

3. The sharply curved lines are carved out with gouges of various radiuses. Cut carefully; otherwise, part of the wood in between can easily be chipped out.

2. The soft forms of the heart-shaped petals are made with gouges. Straight chisels or knives can be used for the tip.

4. Make a vertical cut along the curved lines and then cut again so that a V-groove is created.

Carving flowers

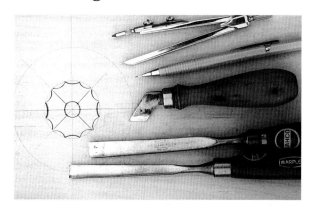

1. Make three circles to indicate the bud in the middle of the flower, the length of the petals, and finally the line from which the outer cuts will be made. Draw four lines to divide the circle into eight equal parts, as shown. Cut the periphery of the inner circle with a gouge, and then cut an evenly distributed wave pattern around the second circle.

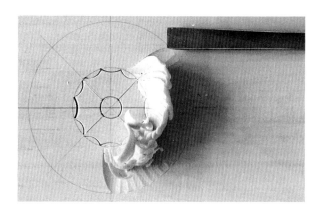

2. Use a gouge to cut from the outermost circle in toward the wave pattern. If the wave pattern was not cut deeply enough it will have to be deepened so the shavings fall off.

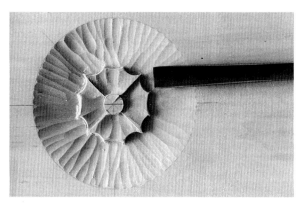

3. Cut vertical lines in the divisions between the flower petals, and then cut the petals with a gouge so that they angle out from one dividing line toward the other.

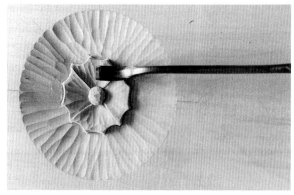

4. A special gouge, sometimes called an inverted curved gouge, is excellent for making the flower bud in the middle. However, a knife or a small flat chisel can be used instead.

ABCDEFGHIJKLM
NOPQRSTUVWXY
ZÅÄÖ
1234567890

Lettering

Letters and numbers can be cut in a number of different styles. They can be freely formed like signatures or they can follow strict lines transferred onto wood pieces with the help of carbon paper.

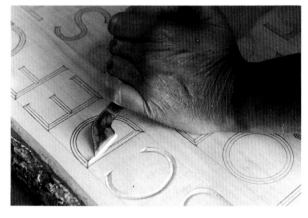

2. Then cut from one outer line diagonally down toward the center line.

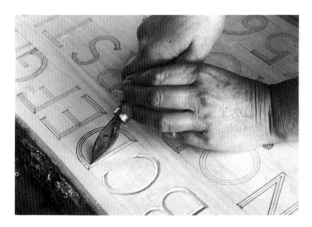

1. In this case the letters have been constructed using three parallel lines to form a V-groove. Start by cutting straight down along the center line.

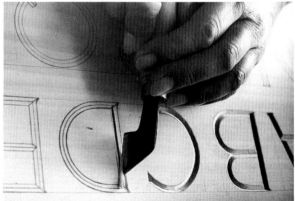

3. Next cut the same way from the other outer line. In the corner where the lines meet a "miter" line will be cut with the greatest depth at the center line.

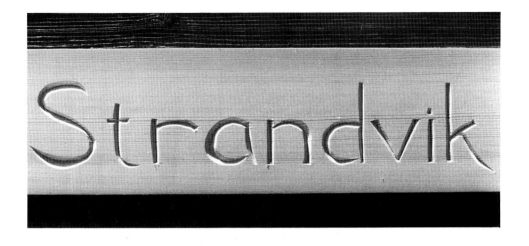

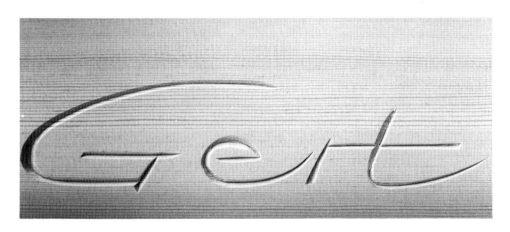

Examples of letters that were more or
less freely cut out with V-grooves.

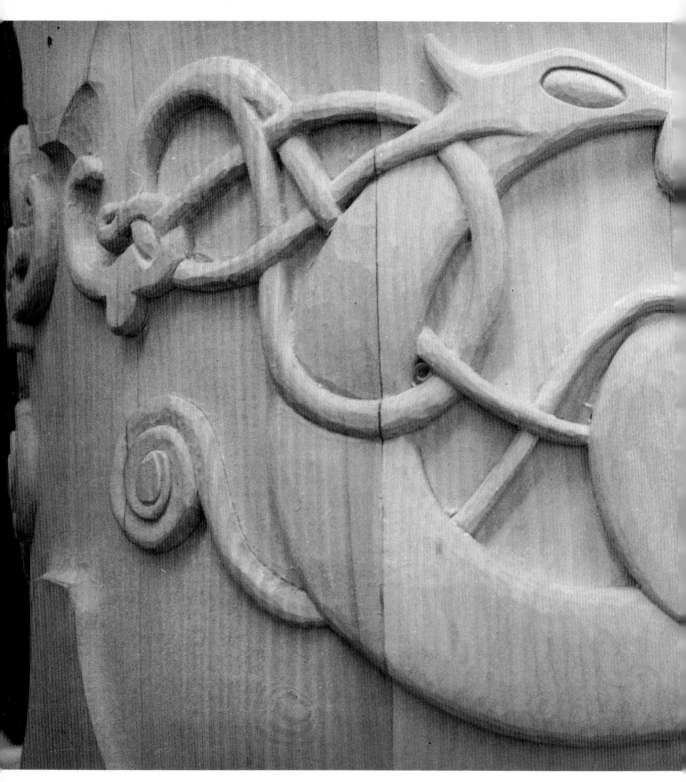

A couple of Midgard serpents make up this relief on the side of a large wooden stave container. The serpents wind their way around themselves and each other on various levels. They must have been carved in stages so they'd look as if they were lying over and under each other.

Reliefs

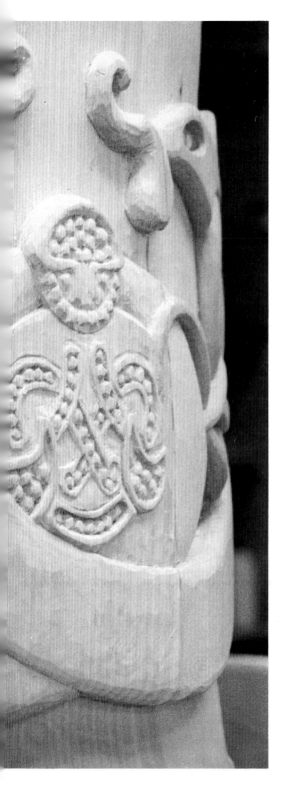

Relief designs can be carved by several methods. The simplest is a flat relief where the entire background lies on one level and the entire motif is on another level. If you want to simplify this you can saw out the entire motif, work the edges, and then glue it to a background. Another related way is to saw out various parts according to their contours, fit them together, and then mount the entire thing on a background.

An actual relief usually consists of using one piece of material to cut a motif down to various levels, and then building on that motif by successively working off the material so that various details are built on, and inside of, each other. Of course, you may need to mix various methods sometimes. You may think that the original material is thick enough in most sections, but discover some limited areas that need to be built on further to achieve the desired depth. Then it may be a good idea to saw out the contours and work them before they are glued into place.

The most suitable material for all relief cutting is undoubtedly straight-growing linden [Editor's note: Linden is more commonly known as "basswood" in the United States]. If you want to make large-scale reliefs it is usually necessary to glue the materials together. Then it is appropriate to use staves, but be sure that the staves are always

To the left: A flat relief with a background lying on one level over the entire surface. The motif also has a level surface with carvings of various contour lines.

The contours on this serpent's tendrils were carved with a knife before the surrounding parts were cut. The double contour line was made with a goat's foot gouge.

Upper right: This relief of carved linden is based on the tales of the Aesir. In the Scandinavian myth of the gods, the story of the Midgard serpent is told: he bit his own tail so that he wouldn't hurt anyone else with his jaws. A natural twig makes the eye of the serpent. The enclosed, circular sections are slightly convex, and where the serpent's tendrils cross, one part has been cut down more to allow sufficient depth for the one above it.

turned so the direction of the grain is as uniform as possible. There can be problems cutting if the grains in two adjoining staves go in different directions. You end up cutting against the grain, which makes it hard to control the cut. Even if most surfaces are worked at a right angle to the grain, it is sometimes necessary to cut along the wood, and then it is important for the various parts to have similar qualities.

A wide range of tools are used for relief cutting. Wood chisels of various widths and gouges of various widths and radiuses are used to cut the contours. For the actual cutting, curved gouges are often best. A thin-bladed and pointy knife, such as a chip-carving knife, is also useful, both for cutting contours and for poking out tight corners.

Bottom right: Another fairly easy way to make a relief is to saw out various parts that fit together and then shape them with a gouge or chisel, or, even better, with a knife. This castle was sawed out in linden, cut down with a knife, and then glued onto a background. Doors and windows have been shaped with the tip of the knife in simple V-grooves.

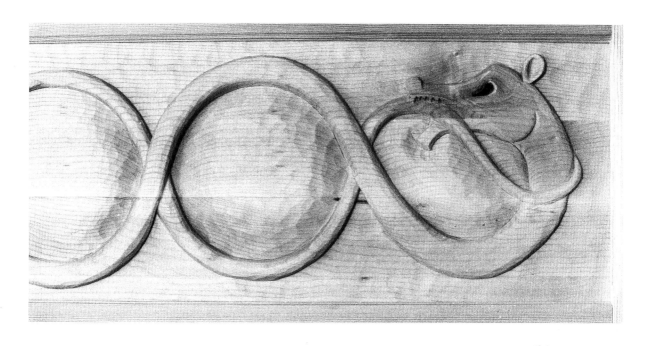

Relief carving

1. The contours with vertical cuts were made with gouges of various radiuses and knives.

3. The resulting surfaces can be left smooth as in a flat relief or shaped further. The lower-lying sections can be further worked into several levels and finally cut with a gouge, preferably across the grain, or stamped with a pattern punch to give a uniform impression.

2. The surrounding parts are removed with the help of a shallow gouge.

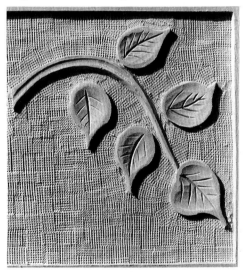

4. With the help of shadows the surface gains life even if the relief is not particularly deep.

Ornament carving

Ornaments are often carved as separate pieces and then mounted on a lower surface.

1. A sketch on paper forms the pattern for the ornament. The sketch is transferred to a piece of wood that is the appropriate thickness. Then the outline is sawed out.

2. Glue the ornament onto a board with paper in between. When the details are narrow and fragile you have to be stingy with glue so it will be possible to loosen the workpiece from the surface underneath later on.

3. Sketch the contours that are going to be the outside edges of various sloping areas. Cut vertical lines with a gouge of an appropriate radius.

4. Cut the various angles with a gouge.

5. When the ornament is complete, it is carefully released from the bottom surface and mounted in place.

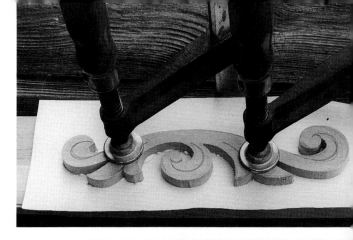

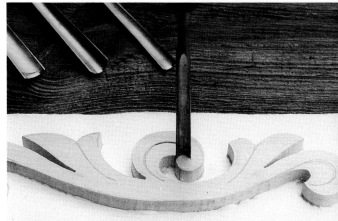

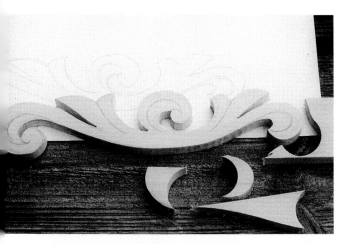

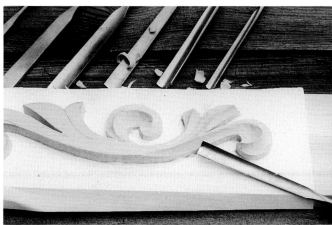

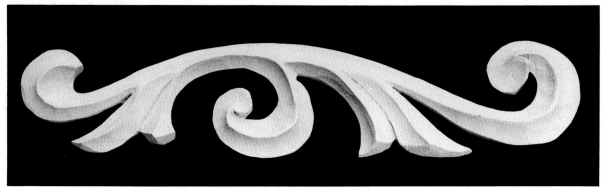

Finishing

In the old days most articles for everyday use were unfinished. The surfaces made with hand tools became velvety and gained a protective patina after daily use and wear and tear, which gave the objects character. Finishing with oils and lacquers, sometimes with color pigment added, was, for a long time, something that was done to only the finest status symbols.

Even nowadays it's doubtful that it's always necessary to apply a finish to woodworking projects. In cases where you really want to touch up something, linseed oil is the best choice. Other oils, such as paraffin oil, are also available. But paraffin oil should be avoided because it doesn't harden. It penetrates the wood and gives it a certain luster, but it never dries, instead it becomes kind of sticky, whereas linseed oil hardens. There are two main types of linseed oil: raw and boiled. Raw oil comes in two different grades: cold pressed and warm pressed. Usually the linseed is cold pressed first. This first pressing gives a very pure product, but it gets only a small part of the total oil from the seed, about 20 percent. Therefore the already-pressed mass is heated and pressed again. Next, various solvents are added to the compound and it is pressed one more time. What you get is a dark oil that contains impuri-

ties and solvents. These are evaporated by heating up the oil. Oil from the last two steps is then mixed together and becomes the raw linseed oil you can buy at the paint store.

In recent years growers of linseed in Sweden have increased production of cold-pressed raw oil. This is a very high quality oil. The problem with raw linseed oil, however, is that it has a relatively long hardening time. To speed this up, drying agents can be added, but this is done partly at the cost of the original purity.

Boiled linseed oil is produced approximately the same way as the raw oil, but when it is heated, air is blown through it at the same time that the drying agents are added, giving the oil a lighter tone.

The raw oil that is cold pressed will penetrate the wood without additives. When using other types of linseed oil, some people add turpentine or petroleum spirits to dilute the linseed oil so that it penetrates the wood better. It is recommended that the first coat of oil be mixed with 60 percent solvent. The following coats can be of more-concentrated oil, which is allowed to penetrate into the surface of the wood until it is saturated. Treatment is completed by using mainly undiluted oil at the same time that the wet oil is polished with abrasive paper. Excess oil is wiped dry before it hardens. This type of finishing gives a tolerable surface that is easy to repolish and oil as necessary.
NOTE!

One detail to keep in mind is that linseed oil generates heat when it hardens. This heat can be so intense that rags and similar things used in treatment can self-ignite! So keep these rags in a jar with a tightly closed lid between treatments. [Editor's note: Store the jar away from sources of heat.]

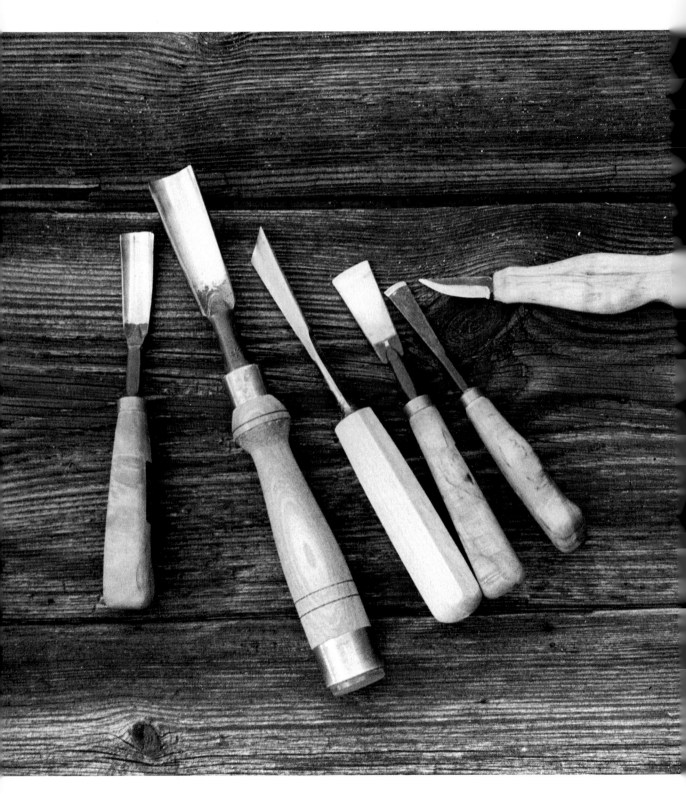

Chisels and gouges of various profiles and curves are needed in the woodworker's
tool set to allow for logical woodworking. On the other hand, you can usually man-
age very well with only one knife, which usually becomes a favorite tool.

Woodworking Tools

[Editor's note: Most tools are ground to shape at the factory but need to be honed on a sharpening stone before they are used. For easy cutting and clean finishes, it's important to keep your blade edges sharp. Both natural and synthetic oilstones and waterstones are available for this purpose. Motorized bench grinders or handcranked benchstones are used to regrind a blade edge that has become misshapen from repeated sharpening or damaged.]

The very first tools used by humans were made of stone. They were probably made for hitting. That they became more effective when equipped with a handle probably didn't take very long for primitive people to figure out. The handle on the mallet is little more than a lengthening of the arm. Most types of stone make chips when they break apart. It is not farfetched to believe that Stone Age people discovered that some stone chips could be used for scraping or even cutting and then developed tools that were directly suited to chopping and carving. In other cultures shells were used early on. These are hard and could easily be honed to a very sharp edge. Approximately at the same time that Scandinavia had a Stone Age, southeastern Asia had a bamboo culture. Segments of dried bamboo stalk become very hard and can be made very sharp on the edge. So various cultures in different parts of the world used cutting tools early on.

With metals came further development of tools. The first metals, such as copper and bronze, were fairly soft and did not stay sharp easily. Since it was not until steel that we got cutting tools that were really good and sharp, it is fantastic how well people managed early on to work with wood.

The cultural inheritance of tool making from Scandinavia's earliest history is carried on

today through the excellent tools this region now produces. While many special tools have been developed, the most basic ones can still be used for a great deal of woodworking. We are convinced that in basements and workshops around Sweden lie numerous old tools that are rusty and without handles. If the quality of the cutting edge is good, the tool only needs to be cut down and resharpened by grinding.

Axes

Axes have been developed from stone axes to our own age's metal woodworking axes. The ax that the woodsman used extensively all the way into the middle of the 1900s, when it was increasingly replaced by the chain saw, was a very heavy and long tool with a slightly down-ward curving handle and (seen from the side) a rounded edge. It had a very thin blade but also a convex bevel that made the edge angle some-what larger so it could survive the great pres-sures it was subjected to. The splitting (or single bit) ax is a thick ax with a relatively short edge. It has a significantly thicker blade that causes a cleaving effect when the cut forces the wood outward on both sides. This is a great ax for such woodworking tasks as splitting thick wood that will be used in woodworking at a later time and that you want to prevent from cracking. The wood should be split in the direction of the grain as close to the pith as possible.

The hatchet is an ax with an exceptionally long edge line. This was the tool used to work lumber for house building in the old days. The logs were shaped so they would fit together and have a somewhat smooth surface. The blades of some hatchets are very thick to shear off thick

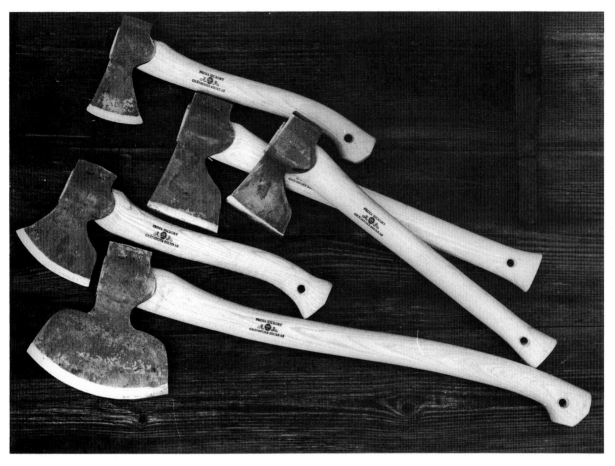

Good woodworking axes. Starting from the bottom: lumber hatchet, the hewing hatchet, joiner's axes in two different sizes, and, at the top, the so-called wilderness ax, which is light and therefore a good woodworking ax.

pieces. Others have a thinner blade for the final hewing. Some have bevels on both sides while others have a bevel on just one side. Some handles lean toward one side to accommodate a more comfortable working position when using the tool for planing.

Woodworking axes are often somewhat smaller and lighter and have thinner blades and straighter bits than other axes. They are not designed to split thick objects or cut across hard branches; rather, they are made for use as chip axes, that is, axes that can work with a smaller amount of material at a time with very fine precision. (There is also a lighter edition of the hatchet with corresponding qualities.) It is an excellent tool for woodworking because it is easy to get this ax to glide along a long edge.

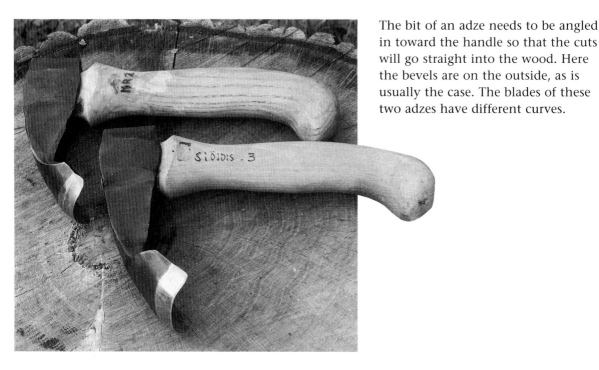

The bit of an adze needs to be angled in toward the handle so that the cuts will go straight into the wood. Here the bevels are on the outside, as is usually the case. The blades of these two adzes have different curves.

The adze, or the hollowing out ax, is another useful tool, which for the most part has been forgotten. The adze is a deeply cupped ax, usually with a very short handle, which is used in hollowing out bowls and troughs. Viewed from the side it has a cupped blade that curves toward the handle to create a suitable angle for chopping out deeper bowls. It is important for the curve of the adze and the length of the handle to agree so that the cut goes straight through the wood. Adzes have bevels on either the inside or outside, although an outer bevel is the most common. The placement of the bevel in relationship to the curve of the adze also plays a specific role. The rounding of the edge of the blade varies from almost straight with upwardly curving edges to a curve with an even radius.

Like the chip ax, the adze is operated more by hand movement than by arm movement, which gives greater precision and also makes handling safer.

The blade of the adze varies from an even radius to almost flat with upturned edges.

Knives

The knife is undoubtedly the most important woodworking tool we have in Sweden.

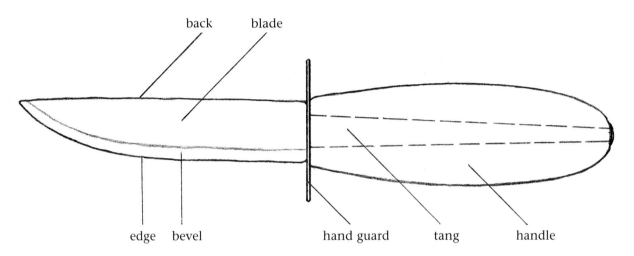

back blade

edge bevel hand guard tang handle

The various parts
of the knife.

In Sweden the Mora knife is a household word. In the past these knives had long, spool-shaped, red wooden handles and blades that were too long and wide for woodworking. In addition Mora knives usually came with a metal hand guard between the handle and the blade to prevent the hand from slipping down onto the sharp edge. This was naturally a good idea if you were going to stab something with the knife. But for woodworking the hand guard was only in the way. If you want to carve with any precision, especially if you are cutting toward yourself, the grip sometimes needs to be such that you partially hold onto the blade. This is particularly true if the blade is of considerable size, like the old Mora knives.

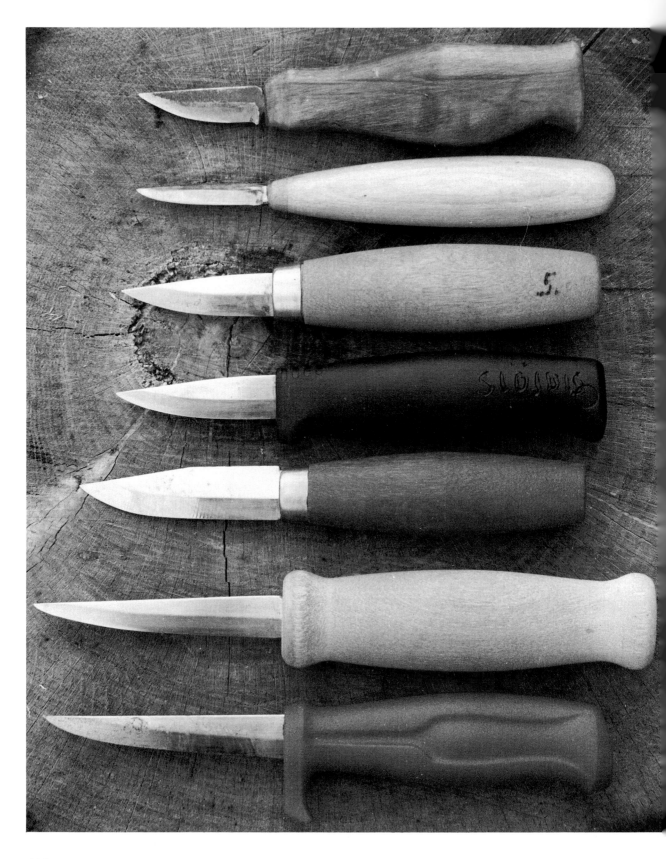

Different types of knives. All except the top two are variations of Mora knives.

The top one is my personal favorite and has been shaped according to my own hand. It has a little, hand-forged blade and its thick handle with its thick center section lies excellently in my hand when I whittle away from myself. Thanks to its narrow front part, this handle is good for holding onto even when whittling toward myself.

The second from the top is a knife with a short and narrow little blade, which in most cases feels weak. The handle is also very delicate.

The third and fourth knives have almost identical blades, very short and pointy. The upper one of the two has a wooden handle of the classic Mora model but somewhat thicker than usual. This knife is one of our favorite among standard knives. The lower of the two has a plastic handle with a slight thickening at the end. This prevents the fingers from sliding out over the blade. However, this handle feels a little sweaty after an hour of uninterrupted work.

There are several different variations of electrician's knives. Knife number five is one of these with the classic red Mora handle. This knife can be used for certain rough whittling, but the blade is too wide in most cases.

Knife number six is also a good woodworking knife with a longer blade, which is flexible thanks to its being relatively narrow. The handle's thicker area in toward the blade provides some built-in protection against slipping that does not significantly hinder your work.

The bottom knife has a plastic handle instead of a wooden handle with a long hand guard. This part is definitely in the way when whittling, especially when you are whittling toward yourself.

Today, Mora knives are made that are excellent woodworking knives with both longer and shorter blades. They come with a wooden handle without a hand guard or with a plastic handle that has a slightly thicker area up toward the edge that is not in the way but gives some protection against sliding if you want to shove the tip into a piece of wood.

With any knife the quality of the steel in the knife blade is of great importance. The most common blades are carbonized steel and rust-resistant steel. Both of these types are all-steel blades: they have the same type of steel all the way through. There are also laminated blades, which have a core or midsection of special steel that can be hardened and a layer of softer steel on each side. The three layers are welded into a blade with different qualities in the center and side sections.

The difference between all-steel knives and the laminated knife is primarily that the former, thanks to its hardening through the entire thickness, is harder than the laminated knife, which has a thinner hardened part. This is why an all-steel knife doesn't bend as easily as a laminated one, but on the other hand it may break if it's subjected to great pressure. Laminated knife blades are becoming less and less common because they are more complicated and significantly more expensive to produce.

There are also several different types of good handcrafted forged blades. These blades can often be purchased without handles, so you can equip them with personal handles that fit well in your hand.

No matter which kind of knife you use, the best will be one that has been in use for a while and sharpened a few times. Then the blade is a

suitable width and the handle conforms to a shape that feels good in your hand.

The handle on a factory-made knife is a universal model which will fit most hands. However, if you want to give your knife personal character you can make your own knife handle. There are several different types to choose from.

The handle can consist of layers or slices of various materials. You drill holes in the slices, thread them on the tang of the blade, and glue them together. (Note that in working with a knife blade, it's important to protect the edge so that it isn't damaged and to protect yourself from being injured. The easiest way to do this is by wrapping a couple of layers of tape around the blade.) The next step is to firmly attach the knife directly to a vise (with the front part of the handle directly against the jaws) and rivet the tang on the end. Then you saw out the handle and shape it. This type of handle is often seen on Sami knives, which are made from various materials such as wood and reindeer antler, sometimes with pieces of metal, leather, or birch bark in between. This is a very complicated method that requires a great deal of work.

It is significantly easier to plane a piece of wood that is double the length of a knife handle, and then cut it in the middle and sketch out the shape and position of the tang on both of the smooth sides, which will later be glued against each other. Then half the thickness of the tang is hollowed out of each section and the halves are glued together. After the glue dries the tang can be riveted on the end in the same manner as in the previous example. Then the handle is sawed out and shaped.

Chip cuts sometimes require special tools.

At the top is a wide straight chisel with a short blade. This is excellent for cuts such as V-grooves

The next three knives are specially forged chip-carving knives. Of course similar ones can be ground from old Mora and other knives. The top one has a somewhat rounded edge line, the next one is straight with a bevel on only one side, and the lower one has a shorter edge line with a bevel on both sides. These knives work wonderfully for almost all types of chip carving.

Tool number five from the top is a broken and well-worn Mora knife; the blade has been thinned out somewhat and is good for tip cuts.

The bottom knife has an extra-thin blade. It was made from just a broken old hacksaw blade sharpened to an edge on the end and equipped with a thin layer of wood on each side, shaped into a handle.

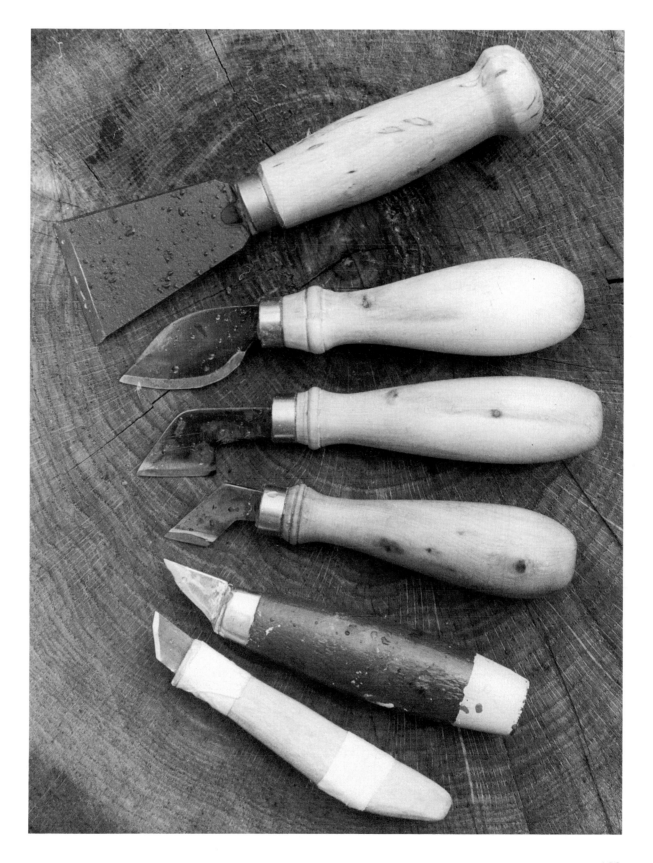

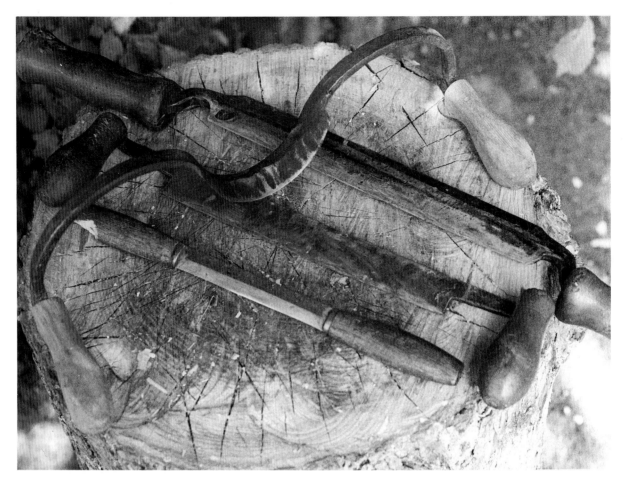

Drawknives

The drawknife and, even better, the push knife are excellent tools for working the outside of bowls and troughs, especially if you are able to attach the workpiece to a carving bench. What separates the two tools from each other is primarily the location of the handles. While the push knife has handles that stick straight out from both ends of the blade, the handles of the drawknife are located at right angles to the blade. The grip of the drawknife is not as well balanced and strong as that of the push knife, and it is more difficult to use when pushing the tool away from yourself. The modern push knife, on the other hand, has the disadvantage of a short blade, and it is difficult to work when pulling

Here are some variations of old drawknives and push knives.

The drawknife with the curved edge lines belonged to an old shoemaker who carved wooden shoes.

The broad push knife at the top has a somewhat strange curve in the handle. It may be an old drawknife with straightened out handles.

In the middle is a drawknife with a bevel on the bottom side.

At the bottom is a small, flexible push knife with a bevel on both sides of its blade.

the blade sideways. The bevel on drawknife blades can either be on the top or the bottom, while the push knife blade is usually beveled on both sides.

The barrel makers and makers of wooden shoes in Sweden also had drawknives of various bends and curves. However these are seldom used today.

Bent carving knives

This is a flexible little tool for the final internal working of spoons and ladles or other tight concave spaces. Some bent carving knives are made with double edges, others with single edges. One disadvantage of a double-edged one is that you can't push on the blade with your thumb when you are cutting away from yourself or put your pointer finger on it when cutting toward yourself. There are a couple of different radiuses on the models that can be purchased in stores, but these are often too wide and clumsy to make flexible curves with.

However there are more-flexible bent carving knives available that are handcrafted by smiths.

Bent carving knives that are flexible are not very easy to get hold of today. Those that can be purchased at hardware stores are usually way too wide.

The top one is an example of such a knife with a wide double edge and a very flat curve.

The second one is also very thick, but after some grinding it should have an acceptable width. It has an edge on only one side and a narrower curve.

The lower two narrower bent carving knives are of good quality. One has a right edge and the other a left edge. In sharpening these narrow bent carving knives you should be careful: cutting too roughly wears the knife down quickly.

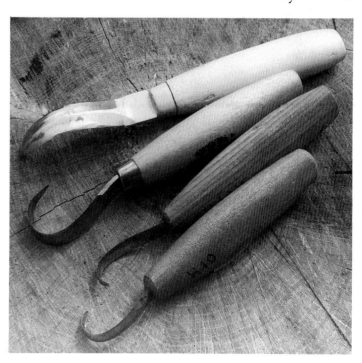

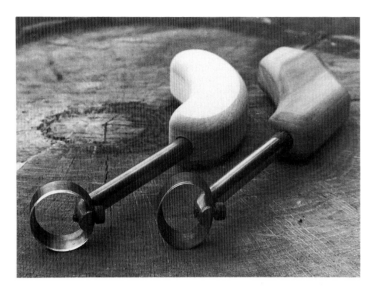

The scorp is a tool that isn't particularly common. By pressing the tool downward at an angle and twisting it at the same time you can cut a considerable amount of material. It's excellent for cutting the inside of smaller spoons and ladles. These two here have different cutting radiuses because one is oval.

These knives have both right and left edges, which means you can cut both toward and away from yourself. They also have good, flexible handles, which means they fit well in your hand.

Cutting chisels and gouges

Various types of wood chisels and gouges are important when cutting wood. Wood chisels have a straight blade with a straight edge line. The widths vary a great deal and they usually have a bevel only on one side. The edge is usually at a right angle to the tools' longitudinal direction. Only the skewed chisels actually have an edge line with an angle. There is also a variation of a wood chisel with a thicker blade, the mortise chisel, that is for cutting out peg holes and similar things. Since this chisel is subject to strong forces that could cause it to break, it is made to be extra sturdy.

For the type of carving handcrafts we are discussing here, various gouges and mortise chisels are significantly more important and more useful than most wood chisels. We mainly distinguish between three types of gouges: straight, curved, and bowed (when looking at them from the

side). It is the longitudinal line of the blade that is straight, curved, or bowed. Of course the blade's edge line also varies, and so does the width and radius of the edge line of the chisel.

For sculpting, relief cutting, and chip carving it's important to have a variety of gouges and chisels in your tool cupboard. Gouges and chisels can

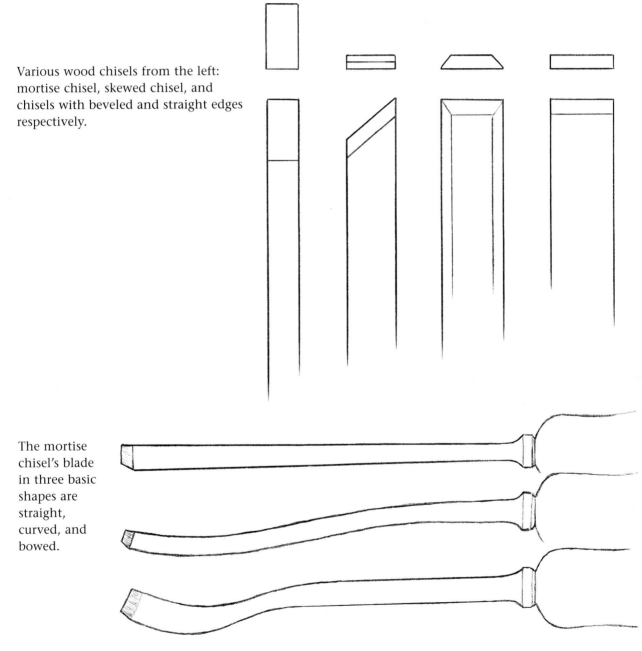

Various wood chisels from the left: mortise chisel, skewed chisel, and chisels with beveled and straight edges respectively.

The mortise chisel's blade in three basic shapes are straight, curved, and bowed.

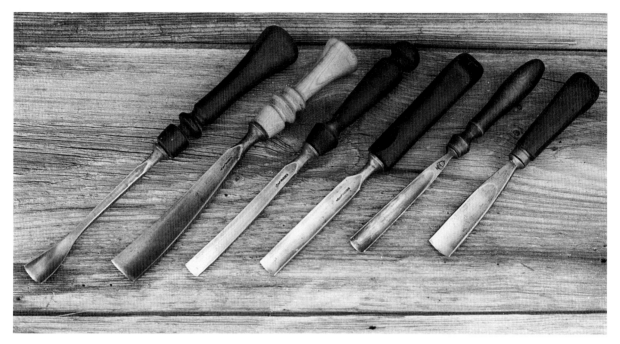

be purchased individually or in sets from hardware stores or various woodworking and hobby stores. The price of a good chisel or gouge can be high. Old gouges and chisels of good quality are often found for significantly lower prices at auctions. These gouges and chisels usually only need to be polished and sharpened and perhaps equipped with new handles to become excellent tools.

Forging tools

The wood chisels and gouges that can be purchased in hardware stores, like the mass-produced knives, are standardized to make production practical and at the same time to suit everyone. They are usually of excellent quality but lack personality and an anchor in cultural inheritance.

In Sweden, a few smiths have taken up the battle of forging tools and make good, functional and beautiful gouges and chisels. One such smith is Hans Karlsson, who lives outside of Motala. He produces our favorite gouges and chisels. He makes a large assortment of wood chisels and

Old chisels and gouges that are sharpened and given handles usually become great chisels and gouges. Here are a few examples of gouges purchased at auctions.

From the left: A bowed gouge, then two curved shallow gouges (which are good for internal final cutting of bowls), and finally, three straight gouges of different widths and with blade edges with different radiuses.

gouges for sculptors and instrument builders. His gouges and chisels are characterized by high quality in the steel and hardening. They have a robust thickness both in their blades and their necks and a solid character in their oxidized surfaces which makes them beautiful.

For a long time a couple of brothers, the Svensson brothers, in Vaggeryd, made themselves famous for their excellent gouges and chisels. Unfortunately, these smiths closed their workshop due to age and the lack of growth in the smith guild. Then Hans Karlsson came along to replace them and took over production and made this assortment his own. By way of continuation the gouges and chisels of the Svensson brothers are now produced by Hans Karlsson.

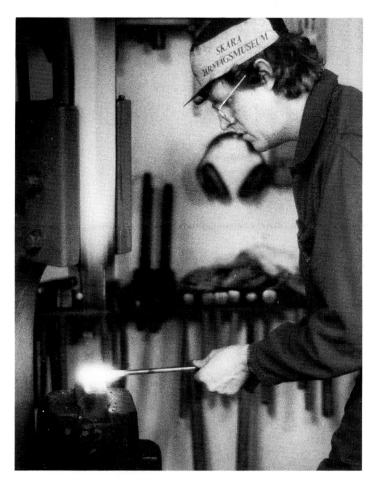

The smith Hans Karlsson, outside of Motala, Sweden, is making our favorite chisels and gouges. Here he is making new "irons" out of round steel.

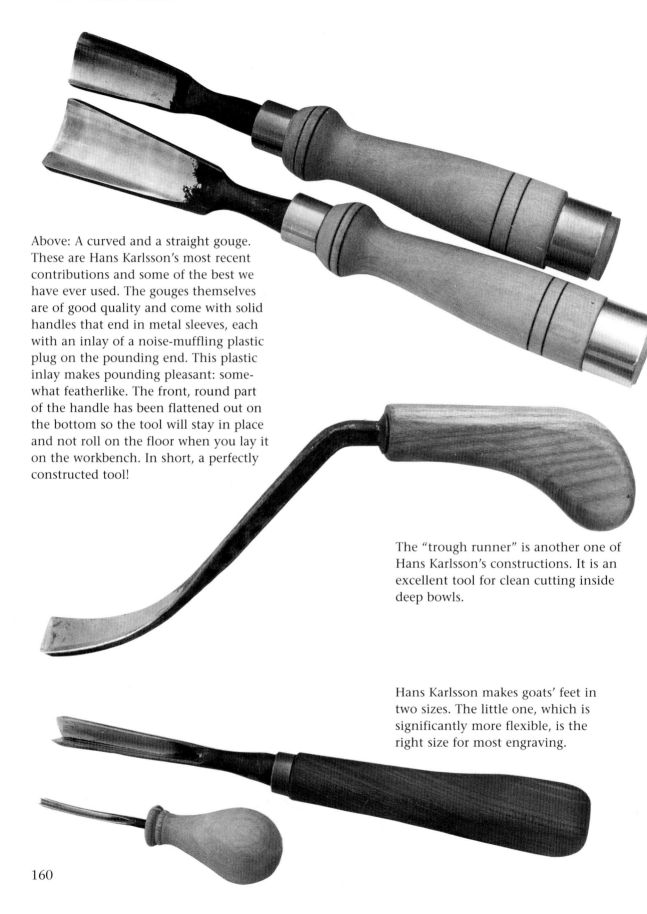

Above: A curved and a straight gouge. These are Hans Karlsson's most recent contributions and some of the best we have ever used. The gouges themselves are of good quality and come with solid handles that end in metal sleeves, each with an inlay of a noise-muffling plastic plug on the pounding end. This plastic inlay makes pounding pleasant: somewhat featherlike. The front, round part of the handle has been flattened out on the bottom so the tool will stay in place and not roll on the floor when you lay it on the workbench. In short, a perfectly constructed tool!

The "trough runner" is another one of Hans Karlsson's constructions. It is an excellent tool for clean cutting inside deep bowls.

Hans Karlsson makes goats' feet in two sizes. The little one, which is significantly more flexible, is the right size for most engraving.

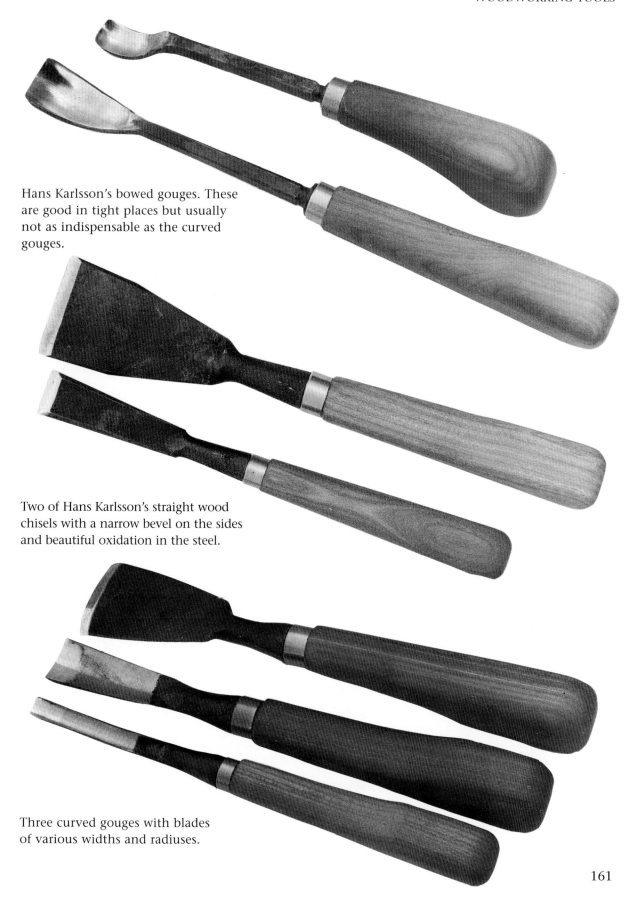

Hans Karlsson's bowed gouges. These are good in tight places but usually not as indispensable as the curved gouges.

Two of Hans Karlsson's straight wood chisels with a narrow bevel on the sides and beautiful oxidation in the steel.

Three curved gouges with blades of various widths and radiuses.

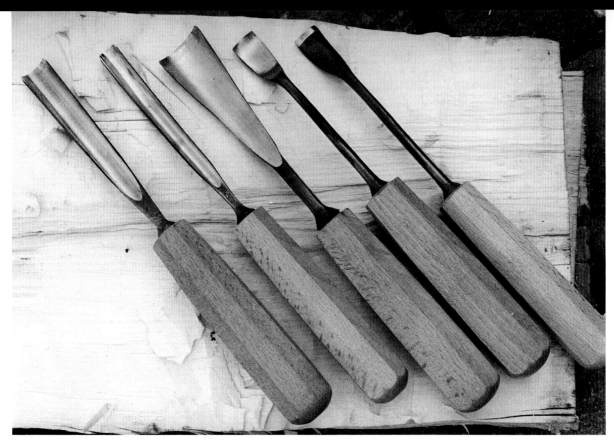

Hans Karlsson has taken over production of the Svensson brothers' assortment of gouges and chisels, which still have the characteristic eight-sided handles.

In the photo from the left: Two straight gouges of varying widths, straight fishtail gouge, bowed gouge, and finally, an inverted bowed gouge for special carving.

Other

The blades of gouges are best protected by storing the tools in a secure location. A small toolbox that has room for the most important tools and perhaps also a hone and oil offers fine protection as long as there are separate compartments.

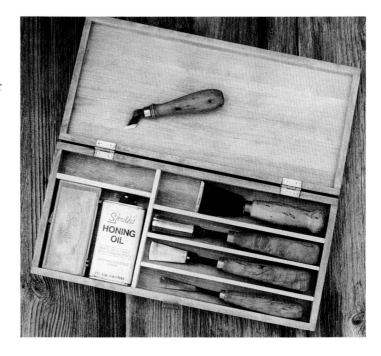

A tool rack is a good solution to the storage problem if the chisels and gouges need to be used in the workshop constantly.

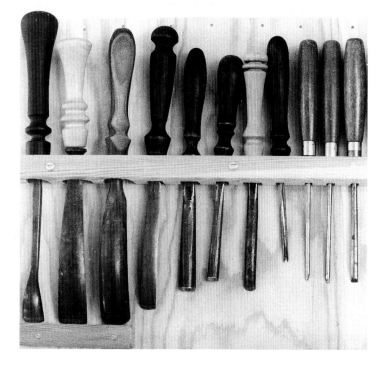

Below: A sewn cloth or leather case that can be carried along easily is a good alternative if you sometimes use the chisels and gouges for working with green wood out in nature. The handles are stuck inside as shown in the photo; then the case is rolled together into a packet.

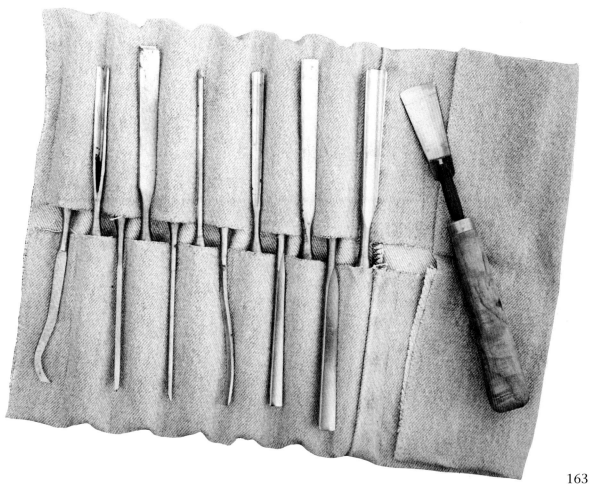

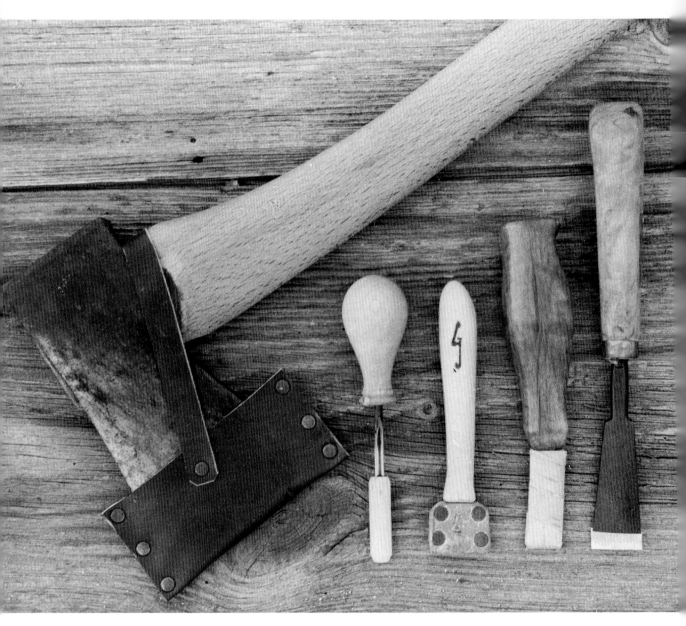

Here are our suggestions for simple and durable protection for tools.

For the bit of the ax you should have a very strong leather protector. This one has been riveted together and is held in place with the help of a strap over the neck of the ax. The strap can be fastened with a snap.

The small goat's foot has a case made from a dowel with the middle drilled out.

The modeling knife, made from an old hacksaw blade, is protected by a small leather case that has been riveted together and covers the entire blade.

The blade of the next knife has a case twined together from strips of birch bark. This is an old-fashioned way of protecting your tools with blades.

Finally, the simplest way of protecting a tool with a blade: wrap a piece of tape around the edge and fold it down on both sides. If the tool is to lie with other tools a couple of layers of tape may be needed for protection.

A practical little case for a knife can be made from a couple of strips of birch bark.

Cut a strip of bark that is somewhat wider than the width of the knife blade and about an inch (2cm) longer than four times the length of the blade. Fold it as shown in the first sketch.

Cut another strip of birch bark. This can be somewhat thinner than the first one, but make it long enough to be wrapped around the entire length of the folded strap. Cut the lower end diagonally and thread it between two of the standing birch bark straps as shown in the middle sketch. Wrap it around the straps in a spiral and pull it out. Cut the upper end diagonally and lock it by threading into the end between two of the standing birch bark straps.

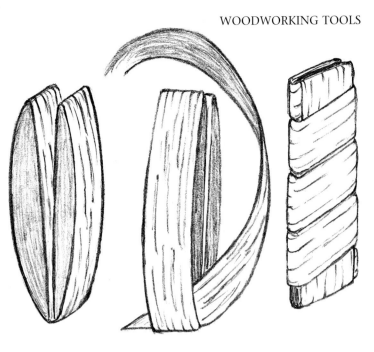

Woodworking mallets are absolutely a part of woodcarving. They can be of varying types. The head can be either in the same direction as the handle or perpendicular to it.

We think the best mallets are those (such as the two on the right in the sketch) with a head in the same direction as the handle and with straight or sloping sides. These give the proper angle between the ends of the chisel or gouge and the pounding point of the mallet.

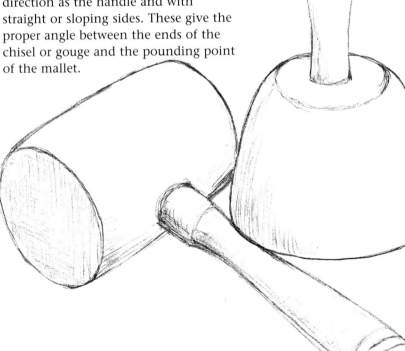

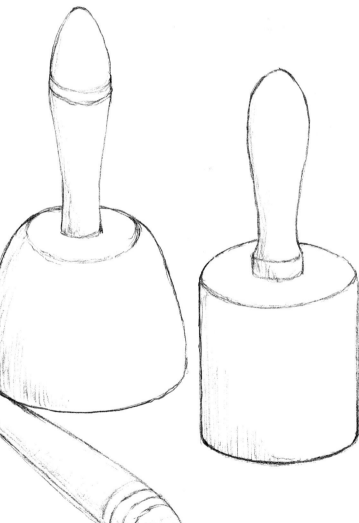

165

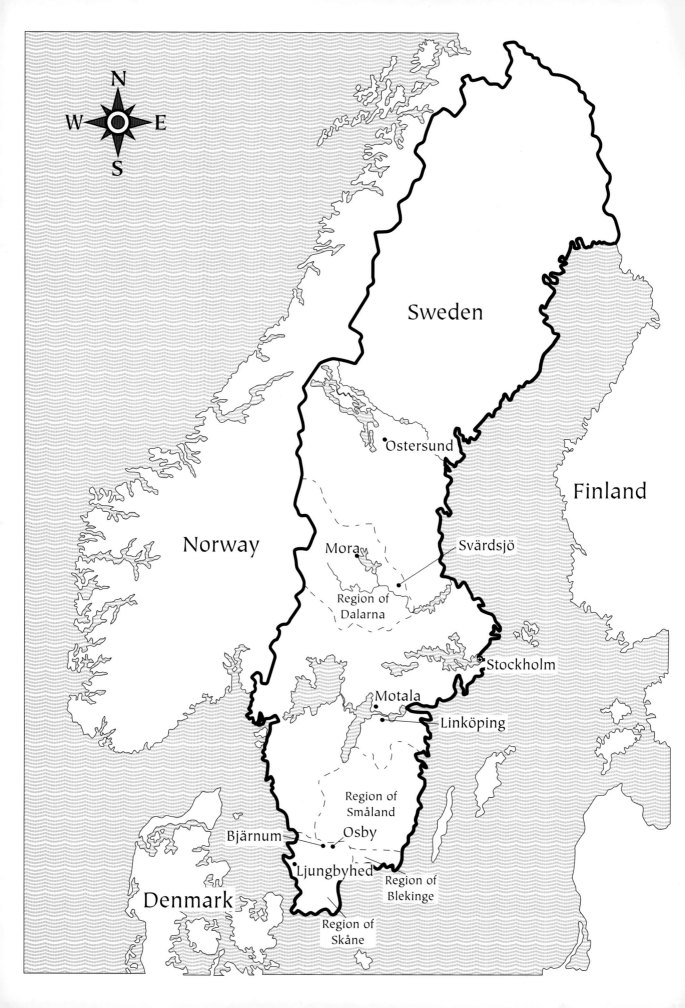